Nicholas Nixon

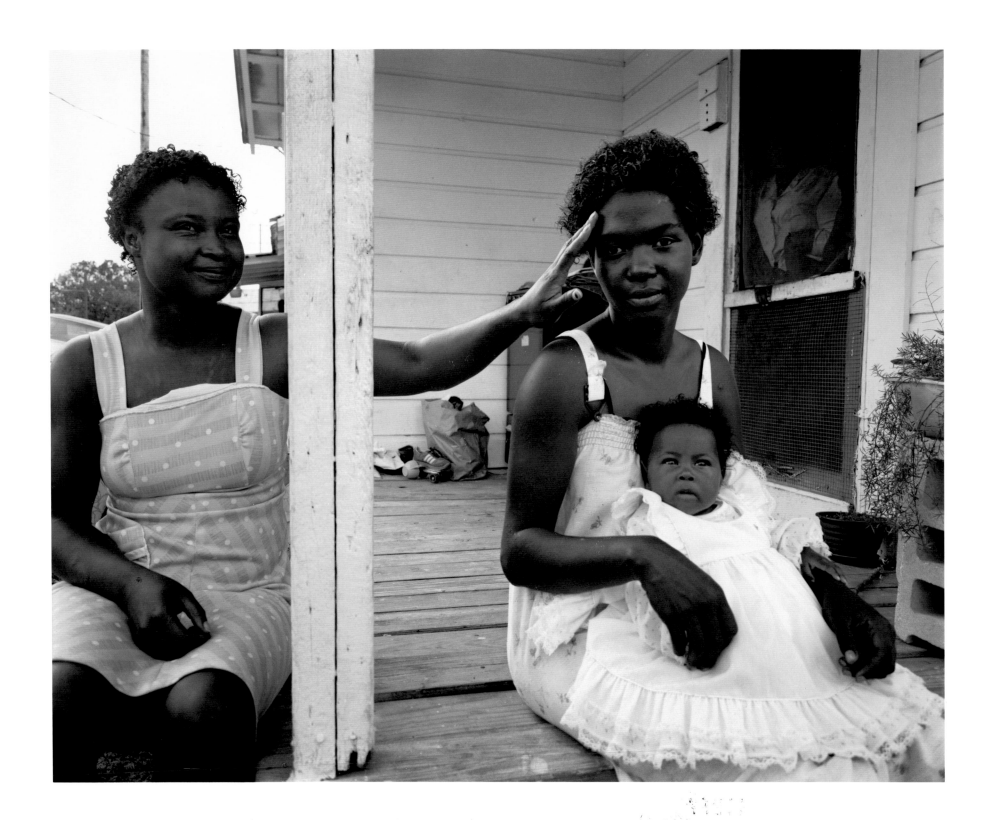

Introduction by Peter Galassi

Nicholas Nixon
Pictures of People

Distributed by New York Graphic Society Books / Little, Brown and Company, Boston

The Museum of Modern Art, New York

This book and the exhibition it accompanies have been made possible by grants from the National Endowment for the Arts and the New York State Council on the Arts. John C. Waddell and Polaroid Corporation have provided additional support for the book.

Schedule of the exhibition:

The Museum of Modern Art, New York
September 15–November 13, 1988

The Museum of Fine Arts, Boston
February 4–April 16, 1989

The Detroit Institute of Arts
May 16–July 2, 1989

San Francisco Museum of Modern Art
September 1–November 5, 1989

There will be additional showings in the United States and abroad.

Edited by Susan Weiley
Designed by James Wageman
Production by Tim McDonough
Halftone photography by Richard M. A. Benson
Type set by Concept Typographic Services, New York
Printed by Franklin Graphics, Providence, Rhode Island
Bound by Horowitz/Rae, Inc., Fairfield, New Jersey

The Museum of Modern Art
11 West 53 Street
New York, New York 10019

Printed in the United States of America
Frontispiece: *Plant City, Florida*. 1982

Contents

Acknowledgments 7

Introduction 9

Plates

People, 1978–1982 30 / Old People 58

At Home 78 / The Brown Sisters 92

People with AIDS: Excerpt from Work in Progress 106

Chronology and Bibliography 121

Acknowledgments

Nicholas Nixon's contact prints, because of their precision and subtlety, present a formidable challenge to the practice of photo-mechanical reproduction. The plates of this book, in the size of the original photographs, meet that challenge with an unusually high degree of fidelity and sensitivity. This achievement is due to the outstanding and imaginative craftsmanship of Richard Benson, who made the three halftone negatives from which each print is reproduced; to the skillful printing of Franklin Graphics, Providence, Rhode Island; and to Tim McDonough's scrupulous supervision of the entire project.

The book and the exhibition it accompanies were made possible by grants from the National Endowment for the Arts and the New York State Council on the Arts. John C. Waddell and Polaroid Corporation provided further, and essential, support for the book. I am deeply grateful for their generosity, which made the difference between good and extraordinary reproduction.

I am thankful to Robert Adams for making available his correspondence with Nixon; to F. I. Brown for sharing his snapshots of his four daughters; and to Lisa Kurzner, Newhall Fellow in the Department of Photography, for her able assistance in organizing the exhibition and the book. Genevieve Christy and John Szarkowski, as well as Adams and Kurzner, read the text and contributed criticisms that I found not only cogent but indispensable. The book's handsome design is the work of James Wageman. I am especially thankful to Susan Weiley, whose deep appreciation of Nixon's work made her a particularly sympathetic and valuable editor of the book.

Most of all I wish to record my warm gratitude to Nicholas Nixon for the pleasure and education of studying his work and for his generous partnership in preparing this book, and to Bebe Nixon for the intelligence and enthusiasm with which she joined us.

P. G.

"Still we know how Day the Dyer works,
 in dims and deeps and dusks and darks."

—*James Joyce,* Finnegans Wake

Introduction

Nicholas Nixon's work of the past decade embraces the idea that sympathetic photographs of ordinary, unnamed people can address the deepest human values. This idea so often has been compromised by moral pretense and sentimental cliché that many photographers have been wary of it, adopting instead a posture of tough-minded irony. On the other hand, the risk of falling into routine sentimentality may be no greater than the risk of succumbing to compulsive irony. Both habits imply that the photographer is superior to the subject, a position Nixon has managed to avoid. His pictures persuade us that we see individuals, not symptoms of a problem or, worse, heroes of the solution. This achievement arises from Nixon's talent for pictorial invention, his sureness of craft, and above all his frankness of purpose, without which the other two would matter little.

In 1974 Nixon earned a Master of Fine Arts degree from the University of New Mexico at Albuquerque. The degree made him eligible to teach photography, which he had chosen as the least disruptive way to make a living while he pursued his work. In the fall Nixon and Bebe Brown Nixon, his wife of three years, moved to Cambridge, Massachusetts. Nixon soon found a job at the Massachusetts College of Art in Boston, where he still teaches part-time.

When Nixon moved to Cambridge he was about to turn twenty-seven. He had decided to be a photographer six years earlier, during his senior year

at the University of Michigan, where he had majored in American literature. Eager to learn what different cameras can and cannot do, he had experimented with at least six, including an 8 x 10-inch view camera that he bought in 1971. Upon moving to Boston he decided to test his ambition to use only the 8 x 10 camera. As a way of applying that test and learning about the city at the same time, he set out to make a good picture of each of Boston's major squares. The work rapidly developed into a series of city views from high vantage points. By the summer of 1976, when Nixon exhibited forty photographs at The Museum of Modern Art, he felt he had exhausted the possibilities of the project. This book and the exhibition it accompanies survey his work since then.

Nixon's view camera stands on a tripod; when unfolded for use it is about the size of a portable television set. At the back of the camera is a ground-glass on which the photographer selects and focuses the inverted image, its dimness made bright by the shade of a dark cloth draped over the photographer's head. The photographer then inserts into the camera, just in front of the ground-glass, a flat case holding a sheet of film; henceforth he cannot see the image. He removes the plastic slide covering the film and releases the cocked shutter in the lens to make the exposure. Even in skilled hands the equipment is cumbersome. It resists rapid revision and punishes sloppiness. Consequently view-camera work conventionally is confined to immobile subjects, which allow the photographer time to study, consider, adjust: to perfect.

The view camera repays the photographer's effort in several ways but the principal advantage is the large negative, which in Nixon's case measures eight by ten inches. The pictorial information contained in a negative of any size is progressively diluted as the image is enlarged into a bigger and bigger positive print. For a print of a given size, the bigger the negative the less it needs to be enlarged, so that the print retains more of the negative's infinite precision of detail and subtle continuity of tone. These qualities reach their apogee when, as in Nixon's work, the negative is not enlarged at all but printed in contact with the positive paper. In a black-and-white contact print, when the sharp and delicate image is organized precisely from

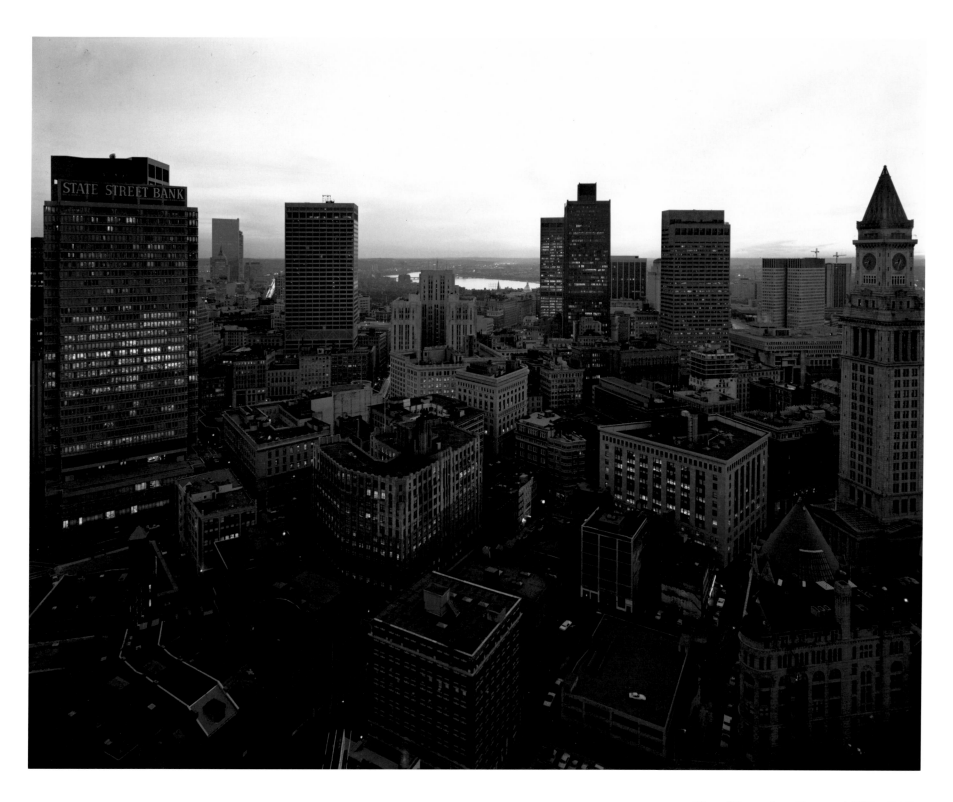

View of Boston from Commercial Wharf. 1975 11

edge to edge so that no area is left unconsidered, the effect is an uncanny, sometimes hallucinatory presence. It is not the presence of reality but an abstraction from reality of the intensity of seeing.

Nixon's Boston views illustrate and exploit the basic qualities of view-camera craft. From looming facade to tiny window pane, the buildings provide a regular progression of scale, which locates the threshold of photographic detail beyond the pale of human vision. At the same time the surfaces are so seamlessly transcribed, the receding geometry so neatly pieced together in the picture plane, that two dimensions unfold effortlessly into three. These formal perfections conspire to create the illusion that the photographer has studied and described his subject with exhaustive care. Nixon himself is no longer interested in the Boston views, regarding them as good solutions to unexceptional problems. Nevertheless, the best of them are not merely tidy but eloquent.

Making the views led Nixon to identify his artistic sensibility with the craft system of view-camera negative and contact positive, an attachment that has persisted and deepened. This craft system is virtually photography's oldest; since the 1850s it has been the unvarying standby of functional work. It is also the medium of high modernism in American photography—the favored medium of Alfred Stieglitz, Paul Strand, Edward Weston, and Walker Evans. In this sense Nixon's work has an old-fashioned aspect, of which he is well aware.

But Nixon's choice of craft also helped to define a new departure. Since World War II the ubiquitous tool of advanced photography had been the hand-held 35mm camera. Worthy exceptions notwithstanding, the central tradition of the 1950s and 1960s had been established by photographers with Leicas: Henri Cartier-Bresson, Robert Frank, Garry Winogrand, and Lee Friedlander. By 1970 the hegemony of the small camera was so firmly entrenched that to begin to photograph virtually always meant to buy a Leica and start prowling the streets. Nixon, like so many others, began just this way.

The Leica tradition, like any dominant style, endowed its artistic prejudices with an air of inevitability. It located modern experience in the public street. It favored the social over the private, energy over refinement, the

eccentric and fragmentary over the carefully composed whole. It identified artistic skill with athletic agility and fostered the notion that technical craft is at best a nuisance and at worst the refuge of the timid.

By the late 1960s or early 1970s the view camera had been out of fashion long enough to represent a fresh opportunity. At least it is possible to say so now because at about that time a number of young photographers— as diverse as Robert Adams, Robert Cumming, Chauncey Hare, and Nixon —began to use the view camera and to make new work with it. Others, such as Tod Papageorge, continued to use the hand camera but shifted from the standard 35mm to the substantially larger 2¼-inch format. A decade earlier Diane Arbus had made such a shift, dissenting from the Leica consensus and anticipating the new, deliberate attitude toward craft. By the mid-1970s a broad range of advanced photographers evidently felt that greater precision of description more than compensated for a loss of speed and mobility. In any case, the shift from smaller to larger format—especially when it required a tripod—tended to alter the relationship between photographer and subject, making it less casual and more formal.

In 1975 an exhibition at the George Eastman House reported on one key aspect of the new view-camera work. *New Topographics: Photographs of a Man-Altered Landscape* presented recent work by eight photographers, five of whom (including Nixon) used view cameras. The show sought to locate the intersection of a subject—inhabited America—and a style of reserve and clarity indebted to Walker Evans and to the vernacular topographers of the nineteenth century, notably Timothy O'Sullivan.

For the exhibition catalogue Nixon wrote a statement, which began, "The world is infinitely more interesting than any of my opinions about it."[1] That this, too, was an opinion does not diminish its earnestness. In varying degrees the other exhibitors shared the opinion. The presence of Bernd and Hilla Becher, whose work was equally at home in the domain of Minimal Art, suggested a breadth of distaste for expressive effect.

In *New Topographics*, the motive of respect for the subject accommodated two divergent attitudes: one admired the beauty of the subject, and risked prettiness; the other faced facts, however unattractive, and risked banality. The first found its purest expression in the work of Stephen Shore

(the only color work in the show), the second in the work of Robert Adams, who had been a guide to several of the others, including Nixon. Nixon's work since the exhibition might be described as an effort to reconcile the two attitudes.

In the spring of 1976 Nixon won a fellowship from the John Simon Guggenheim Memorial Foundation. He used part of the money to buy an 11 x 14-inch view camera and the rest for a three-month trip across the country to photograph the landscape: a bigger camera, bigger contact prints, a bigger subject. When he returned in the fall he developed and printed his work, studied it, and ultimately decided it was a failure. A year later he sold the camera. He was back where he had started, except that a stint with the difficult 11 x 14 camera had reconfirmed his attachment to and proficiency with the 8 x 10.

After the cross-country trip, Nixon continued working at ground level, avidly but unsystematically photographing in and around Boston and Cambridge. In the spring of 1977, while still using the 11 x 14, he sought to impose a degree of conceptual order on this work in the form of a plan to describe life along the Charles River, which divides the two cities. But the challenge that increasingly preoccupied Nixon was pictorial, not conceptual.

The Charles River landscapes often included figures in the distance. In the early summer of 1977, returning to the 8 x 10, Nixon began to concentrate on the figures as an animating presence in the landscape. By the end of the year the figures had won his attention from the scene. That fall Nixon began to see how close he could get to people before the ponderousness of his view camera defeated their vitality—and before he lost control of the picture. Although he continued for a time to make landscapes, and found them much easier to make, the challenge of photographing people was foremost in his mind. In July 1979 he wrote to Robert Adams, "Have gone back to pictures of people; all of a sudden it was there, necessary, more open-ended than ever, and somehow (forgive me) important. Just developed a hundred today and am real pleased." The project continued through 1982.

Nixon relished the practical aspect of the challenge. He loved testing just how quickly he could plant the camera, aim, focus, load, and shoot. He

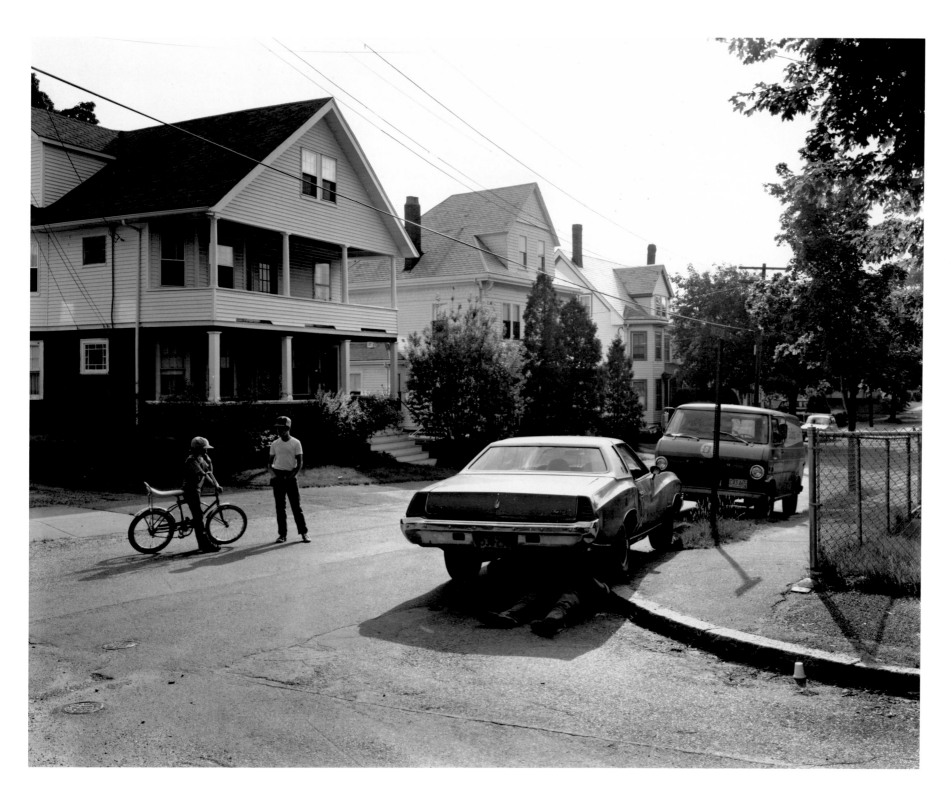

Riverside Street, Watertown, Massachusetts. 1977 15

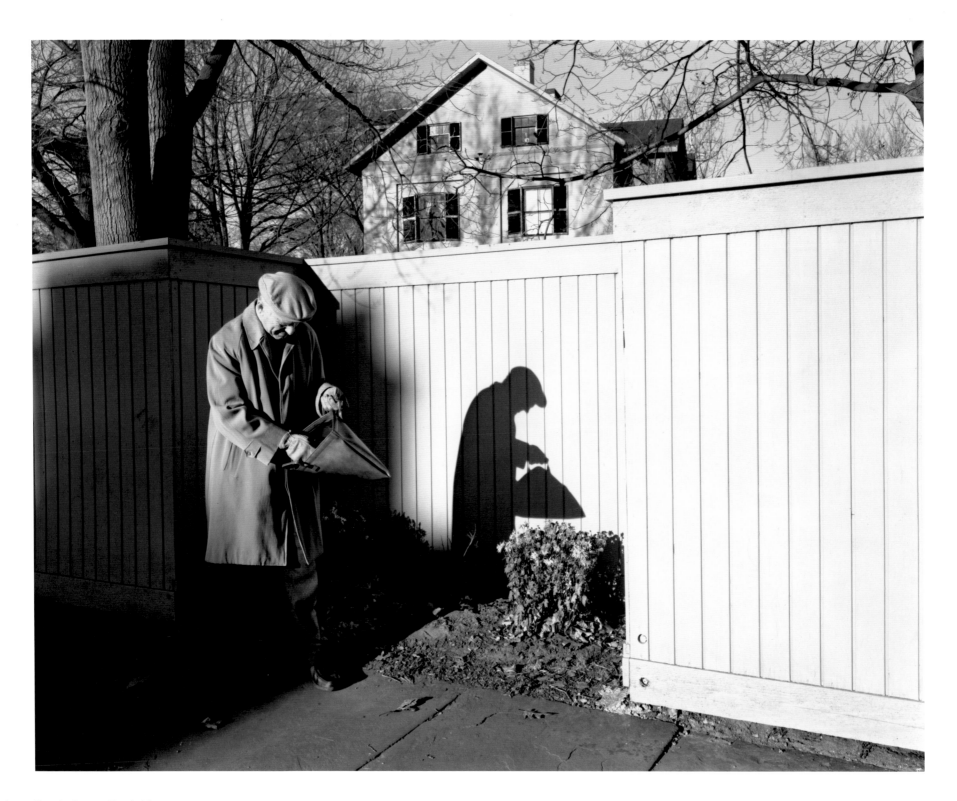

16 *Brattle Street, Cambridge. 1977*

learned which neighborhoods, at which times of day, were most likely to offer plenty of people outdoors who might accept or even welcome a brief interruption for a picture. For there was, inevitably, an interruption. No matter how adept he became, Nixon could never coax from his camera the agility of the Leica. It stood between him and his subjects like a contract. The challenge—for the photographer and his subjects equally—was to overcome legal formality, to reach the frankness of a handshake.

Only once or twice did Nixon take his camera inside. Otherwise he photographed people outdoors, sitting on their own front porches, or at the beach, where a small group, although surrounded by strangers, creates for itself an atmosphere of intimacy. Poised between their public and private selves, the people adopt a mood of unlabored decorum.

The work grew slowly. At first, in 1977, the frame sets a stage on which the figures, like actors, make appearances. In 1978 and 1979 the figures fill the rectangle, but it often flattens and constrains them. By 1980 the geometric scaffold has dissolved into depth and the figures, increasing in number, deploy themselves freely; the frame, lithe and agile, now responds to them. Twice between 1977 and 1980 Nixon shortened the focal length of his lens, thus widening the angle of view and increasing the depth of focus. The shorter lens also changed the character of the pictorial space, making it more lively and palpable. Instead of rendering flat shapes, the picture leads the eye over contours and as if around corners, giving the figures volume and weight and animating the space between and around them. Here again the luscious tonal continuity of the contact print plays a crucial role, fulfilling the generous promise made by the broad field of the lens.

Photographs had not looked like this before, although the view-camera tradition was rich in precedent. Nixon made many of his pictures of 1981 and 1982 in the South, where he was able to work earlier in the spring and later in the fall. The locale alone invites reference to Walker Evans's work of the 1930s, a comparison that stresses the apparent spontaneity of Nixon's work. Alternatively, the sensuality and formal unity of Nixon's pictures may remind us of the photographs of Paul Strand. But here, too, the comparison calls attention to Nixon's responsiveness to the flux of experience, and his openness to the variety of personality.

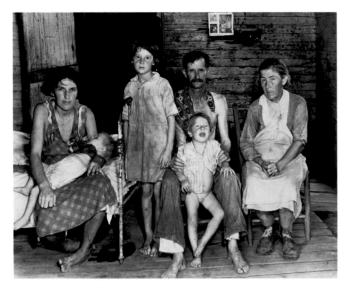

Walker Evans. *Sharecropper's Family, Hale County, Alabama.* 1936

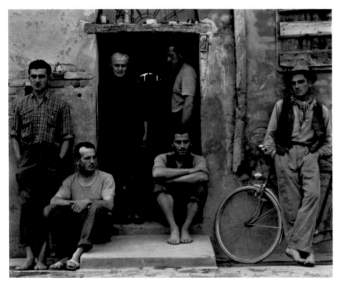

Paul Strand. *The Family. Luzzara, Italy.* 1953

Among more recent precedents there were Bruce Davidson's photographs of people in New York's East Harlem, published under the title *East 100th Street* in 1970. The work struck many observers as a bold application of the view camera to a complex and difficult subject. Nixon recalls that the book impressed him and helped prompt the purchase of his first 8 x 10 camera in 1971. Nevertheless, compared to Nixon's, Davidson's pictures seem psychologically opaque and pictorially at once simpler and less resolved.

The relationship of Nixon's style to the prior view-camera tradition cannot be understood apart from the overlapping hand-camera tradition, whose pictorial style had evolved toward an ever wider scope of view and an ever greater number and precision of moving parts. The trend reached its peak in the manic complexity of Garry Winogrand's photographs of the late 1960s and 1970s. Although in subject and sensibility Winogrand's work is distant from Nixon's, its style provided an essential resource. Nixon's work between 1977 and 1982 thus may be described as an ambitious, even foolhardy gambit: to annex advanced hand-camera style to the old-fashioned, intractable view camera, and thus to merge the spontaneity and suppleness of the former with the deliberateness and descriptive abundance of the latter.

That Nixon succeeded so well is impressive, but the achievement would be pointless without the psychological content of the pictures. Indeed it is the psychological aspect that makes the formal problem difficult. Like the hand-camera tradition it extends, Nixon's work is not a matter of shapes artfully arranged but of characters precisely described, as individuals and in relation to each other. The lively wholeness of each picture, the coherent grouping of independent characters, is a metaphor for personal and social connection.

In a splendid essay on these photographs, Robert Adams concluded:

We realize only upon review of figure after figure in picture after picture that there are no villains—none. No one is contemptible (for comparison, think of photographs in news magazines). More astonishing, there is not a face that is uninteresting, not an individual for whom we could not hold some respect and hope.[2]

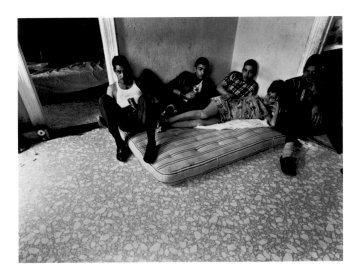

Bruce Davidson. Untitled. 1967–68. From *East 100th Street*

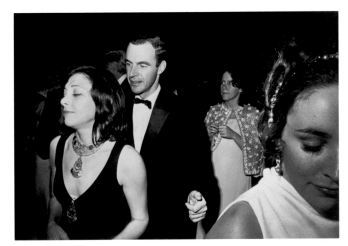

Garry Winogrand. *Centennial Ball, Metropolitan Museum, New York.* 1969

It is plain to see that most of the pictures were made in poor or working-class neighborhoods, where barriers of privacy are less firmly established than elsewhere, and where Nixon was drawn by the openness he found among people. This openness brought with it a liability to trespass, and the memory of photography's record of trespass upon the lives of the poor. Nixon accepted the liability in much the same spirit that Eudora Welty had accepted it when she set out to photograph life in Mississippi in the 1930s. Later she recalled:

> And had I no shame as a white person for what message might lie in my pictures of black persons? No, I was too busy imagining myself into their lives to be open to any generalities. . . . I knew this, anyway: that my wish, indeed my continuing passion, would be not to point the finger in judgment but to part a curtain, that invisible shadow that falls between people, the veil of indifference to each other's presence, each other's wonder, each other's human plight.[3]

There are no victims or heroes in Nixon's photographs. And although the pictures are beautiful, even luxurious in their sensuality, the photographer's choice of subjects was indifferent to any canon of beauty, above all to our aggressive contemporary cult of fitness and youth. Nixon judged his subjects solely by their candor, and kept his part of the bargain by accepting candor at face value. The viewer must decide for herself or himself whether the candor of Nixon and his subjects is genuine. The criteria for this decision are not aesthetic; they are the same criteria we apply, and must ourselves try to meet, in any human exchange.

Many artists work in series, each series charting the discovery, definition, and resolution of a discrete artistic problem. Part of the problem always is practical. For a photographer the practical aspect includes identifying and gaining access to the subject. For a view-camera photographer, the trouble is magnified by the cumbersome and restricting equipment. Every false start exacts a penalty of energy and time, and dilutes the mental clarity that lies behind all good work. False starts of course are necessary, since it is impos-

sible to know in advance which will prove true. Each year Nixon begins and abandons several potential series, some of which leave behind isolated successes, such as the picture on page 23, from the intermittent Charles River project. But these pictures come at the cost of too many failures. The neatness with which Nixon's photography so far divides itself into discrete series thus reflects the deliberateness with which he has focused his energy.

The pictures of groups of people—the front-porch pictures, they might be called—remained a challenge for an unusually long time, from 1977 through 1982. After a slow start Nixon had mastered and thus in effect could ignore the practical mechanics of the series. By mid-1983 he was at loose ends again, eagerly hoping that a new project would take root. A year earlier he had begun to volunteer at a Boston nursing home; breaking an initial contract with himself, he began to make photographs there. The project continued through 1984 and 1985.

The elaborate design of the front-porch pictures soon gave way in this new work to a style of simplicity and austerity: isolated figures; heads frontal or in profile; details of faces printed larger than life. One might, inadequately, attribute this development to the self-sustaining momentum of pictorial inquiry. Broadly speaking, since the mid-1970s Nixon had been moving closer and closer to his subjects. Although not untrue, the explanation ignores that the subject had changed, and with it the sense of the pictures.

Old people in general and nursing-home patients in particular are familiar subjects for photography, especially for photography designed to arouse sympathy or concern. Such work often conceives of the subject as a problem that is susceptible to solution or at least improvement: the corrupt administration of nursing homes, for example, or the neglect of the old by the young. By contrast, Nixon's work describes not a problem but a fact: human beings get old and die. No medical advance, no new efficiency of social services, no regeneration of morals will change it. Were it not for the undissembling boldness with which Nixon faces this fact, the tenderness of his pictures would be far less persuasive.

Nixon had begun (and continues) to visit the home to help out a little bit, mostly by giving people a chance to tell their stories or by escorting

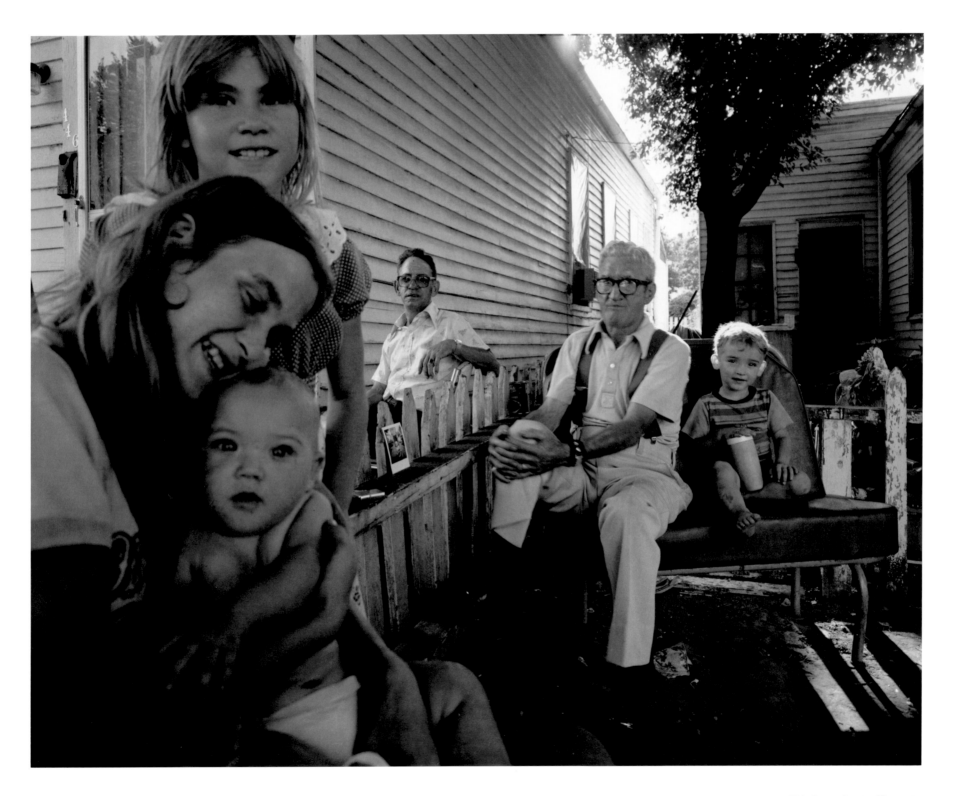

Twenty-fifth Street, Louisville. 1982 21

them outdoors. Some of the people also enjoyed seeing Nixon's dog or his young son, Sam, and some liked the photographs he gave them—his black-and-white prints or, better, Polaroid color snapshots. But the pictures are not about the personal attachments Nixon formed, some of them quite close.

Perhaps a few readers of this book will know a few of the subjects. For others an unjust picture cannot be justified because subject and photographer are said to have cared for each other. If the pictures do not move us, it will not matter that this writer, not present when the pictures were made, asserts that Nixon was moved.

Unlike the front-porch pictures, which involve the question of relation, Nixon's pictures of old people are unconditional, solitary portraits of particular individuals. Yet the relentless specificity of the physical description carries us beyond the psychological aspect. These portraits of individuals are also images of mortality. Their terrible beauty and iconic grandeur address death with impersonal gravity, uncorrupted by pity.

Samuel Hunter Nixon was born in November 1983, about the time that his father began to think of the pictures of old people as an extended series. Clementine Culver Nixon was born in November 1985, when the series was coming to an end. At work and at home the father, himself nearly forty, lived with the extremes of age. One might suggest that Nixon began photographing his children as part of an ambitious artistic scheme on the theme of age. Perhaps it would be closer to the truth to say that he did so for the same reasons that most fathers do and because, unlike most fathers, he was able for a time to work at home.

All of Nixon's work is rooted in the physical fact of identity, the fact of each finite person in one finite body. The tie between person and body, although infinitely variable, is irrevocable. Thus photography, although it may seem to describe only the body, at its best also can describe the person, or an aspect of the person. Nixon had pursued this capacity with great subtlety and precision. Now, photographing his family, he turned his pursuit narrowly to the physical.

Charles River, Cambridge. 1982 23

Most of Nixon's subjects had been strangers. Now his subjects were intimate to him, and willing if occasionally obstreperous or cranky. Nixon indulged his senses, undressing his family and photographing their bodies with unembarrassed zeal. The compact frame is unequivocal; the seamless volupty of the contact print in black and white—it would not be so in color—abstracts from life the vitality of flesh, its beauty and promise.

With this work Nixon came closer than he had before to the old American view-camera tradition, specifically to Edward Weston's nude studies of his lovers (especially his wife Charis) and his children (especially his son Neil). Nixon's nudes do depart from Weston's idealism of the 1920s and early 1930s—as did Weston's own later work—in the same way that actual bodies depart from the forms of ideal art. The departure became all the more clear in the spring of 1988 when, a year after completing the series, Nixon returned to it, and personality and anecdote invaded the work. All the same it is worth pondering Nixon's willingness to enter an artistic territory that others had mapped so confidently before him.

Our culture, familiar with a correspondence between originality and quality, habitually equates the two. The equation burdens artist and audience with an expectation of prominent formal or conceptual invention, an expectation that precedes and often obstructs the pursuit of other values. Nixon's photography as a whole, not only the nude studies, invites us to reconsider the habit. Like some other current work, it suggests that the prior exploration of a broad artistic territory might not preclude the later discovery within it of pictures as good as, or better than, the first. A few years before Nixon began the nudes, Jan Groover was photographing peppers, in part, she has explained, to prove that Weston "does not own them."

Nixon had not planned it, but age had become a central issue in his work. Doubtless this was partly because photography, although awkward at telling stories, has the capacity to describe age, or the physical expression of age, and thus to evoke the arc of a life. That capacity underlies Nixon's series of annual portraits of his wife and her three sisters, which began in 1975.

With the second picture, in 1976, the five participants settled upon two constants: a single picture each year (no matter how many negatives Nixon

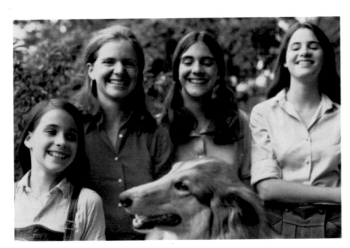

F. I. Brown. *Mimi, Bebe, Laurie, and Heather Brown.* 1970.

exposed or how good the alternatives) and an unvarying line-up (from left to right: Heather, Mimi, Bebe, Laurie). A third, unstated constant was that each of the four women would look at the camera, and that each should be not just physically but psychologically present. At this writing in early 1988 the series numbers thirteen.

The pictures are family snapshots. Nixon has replaced the casual competence of the genre with high technical skill, uncommon psychological acuity, and unfaltering regularity. Of course we cannot read the pictures, least of all cherish them, as family members might. But otherwise they function as snapshots, to mark time. One following the other, the photographs are dense with allusion to the year of life lived between each one and the last.

One might expect that the systematic structure of the series—the fixed sibling relation of the four women in a row, the unvarying interval of time—might give it a quasi-scientific aspect, as if it might be used as reliable evidence. In fact the series presents a fluid image of time, complex with eddies and pools, swells and calms. Each portrait, stable in isolation, is qualified by a rich store of resemblances and differences, which cannot be reconciled to a single linear narrative. Age, identity, family relation are not pictured as fixed qualities but as pliable threads within a fertile and provisional view of experience.

It is by now a familiar observation that no two photographs are exactly alike, that the medium is inherently plastic. Nixon's pictures recast the observation, suggesting that it is not photography but experience that is plastic, a quality made plain by photography's mechanical precision.

In 1975 the Brown sisters ranged in age from fifteen to twenty-five. In other words, the series begins at the threshold of adulthood, when expectation has not yet been revised by experience. It begins at a beginning and thus promises the whole of a life.

Toward the end of 1986, about the same time that Sam turned three and Clementine one, Nixon could see that the series of nude studies—or what later turned out to be the first patch of them—was coming to an end. In the interlude over the winter and into the spring, while he considered what to

do next, he made some still lifes of apples and, with a new 11 x 14 camera, continued photographing his family. By the early summer of 1987 he had decided to devote his best effort to photographing people with AIDS. From the beginning Bebe Nixon, a science journalist, has been a partner in the project. Her interviews with the people in the pictures, and sometimes also with family or friends, will be part of the finished work. At this writing the project is far from complete.

It was the first time Nixon had chosen a subject that was an issue of public importance, let alone one so charged with emotion and controversy. Always before, he had been drawn to a subject by a visceral intuition of how the pictures should or could look, leaving for later what they might mean. Now the subject was defined first as an idea, and one whose significance outweighed Nixon's private artistic mission. With this came the hope that if the pictures were good they might matter, not in the sense that all good art matters, but in a specific sense having to do with AIDS.

By the end of 1987 the work had taken the form of several extended sequences of portraits of individual people with AIDS, taken at intervals ranging from a week to a month. Sometimes the subject is joined by a lover or a family member or a friend. The richest of the sequences so far is reproduced here, on pages 107–119, as a report on the work in progress. It began in August 1987 and ended in February 1988 with the death of Tom Moran, the subject.

Any portrait is a collaboration between subject and photographer. Extended over time, the relationship can become richer and more intimate. Nixon has said that most of the people with AIDS he has photographed are, perhaps because stripped of so many of their hopes, less masked than others, more open to collaboration.

The sequence records the passage of time, the harrowing progress and cruel finality of AIDS. It also draws us to the individual in his or her particularity in a way that isolated portraits may not. It seems to this writer that if the pictures matter it is because of the particularity—the untimid tenderness—of the attention they pay to the individual people they describe.

Leaving aside the most contemptible responses to AIDS—unbending prejudice, racism, political cowardice—the vastness of the epidemic tends

to overwhelm even the most genuine concern. In a recent interview Gary Indiana made the point this way: "One terrible thing about this epidemic is that it has taken away the concept of having one's own death, and made thousands of deaths into this kind of generic tragedy, which is really not even perceived as a tragedy by the culture at large, which is pretty horrifying to begin with."[4]

At this writing more than 60,000 people in this country have been stricken with AIDS. The effort to make a bridge between this appalling number and the individuals counted within it is what gives poignancy to projects such as the Names Quilt, each square of which is handmade by lovers or friends or family to commemorate the life of one person dead of AIDS. Nixon's is a related effort. Although his subjects are far too few to constitute a demographic sample, they knowingly present themselves— and Nixon presents them—as people with AIDS and thus as representatives. Beside and against this fact is the irreducible fact of the individual, made present to us in body and spirit. The life and death of Tom Moran were his own.

Nixon's camera and his black-and-white contact prints are old-fashioned. His pictorial innovations, although masterful and even breathtaking, seem less to open a new territory for others to explore than to realize an opportunity created by earlier work. Photographic tradition, in its headlong, spendthrift course, had forged a consensus that the opportunity was used up. The surprise of Nixon's work, not once but again each year for over a decade, has been the proof that this was not so.

For some time it also had appeared that photography's capacity for empathy was used up. As a means of engaging the heart, photography seemed badly compromised by pictorial and moral cliché, which buried the individual in the type and poisoned feeling with sentimentality. As if in reaction, the photographer became a detached observer. In the 1960s photography's image of human experience was confined almost entirely to public places and social behavior. Only Diane Arbus, photographing society's outsiders, cut through the public scene to the private person and made herself emotionally present in her work.

Nixon's first pictures of people extended and challenged the mainstream hand-camera aesthetic of the 1960s. As the work has matured it has grown closer in spirit to Arbus's work. As Nixon's subjects have become more vulnerable, the conviviality of the front-porch pictures has given way to a mood of tenderness and intimacy, still, deep, and moving. The self-evident mastery of craft, the flourishes of style, have dissolved into lucid, unembellished description.

If Nixon began with the most basic artistic motive—to make something clear and beautiful and new—that motive has transformed itself. Making pictures has become a way of finding a path to the heart.

Notes

1 Quoted in William Jenkins, *New Topographics: Photographs of a Man-Altered Landscape*, exhibition catalogue (Rochester, N.Y.: International Museum of Photography at George Eastman House, 1975), p. 5.

2 Robert Adams, "Introduction," *Nicholas Nixon: Photographs from One Year*, Untitled 31 (Carmel, Calif.: The Friends of Photography, 1983), p. 8.

3 Eudora Welty, *One Time, One Place: Mississippi in the Depression: A Snapshot Album* (New York: Random House, 1971), pp. 6, 8.

4 Gary Indiana, untitled interview, *Artforum*, vol. 26, no. 6 (February 1988), p. 77.

Plates

People, 1978–1982

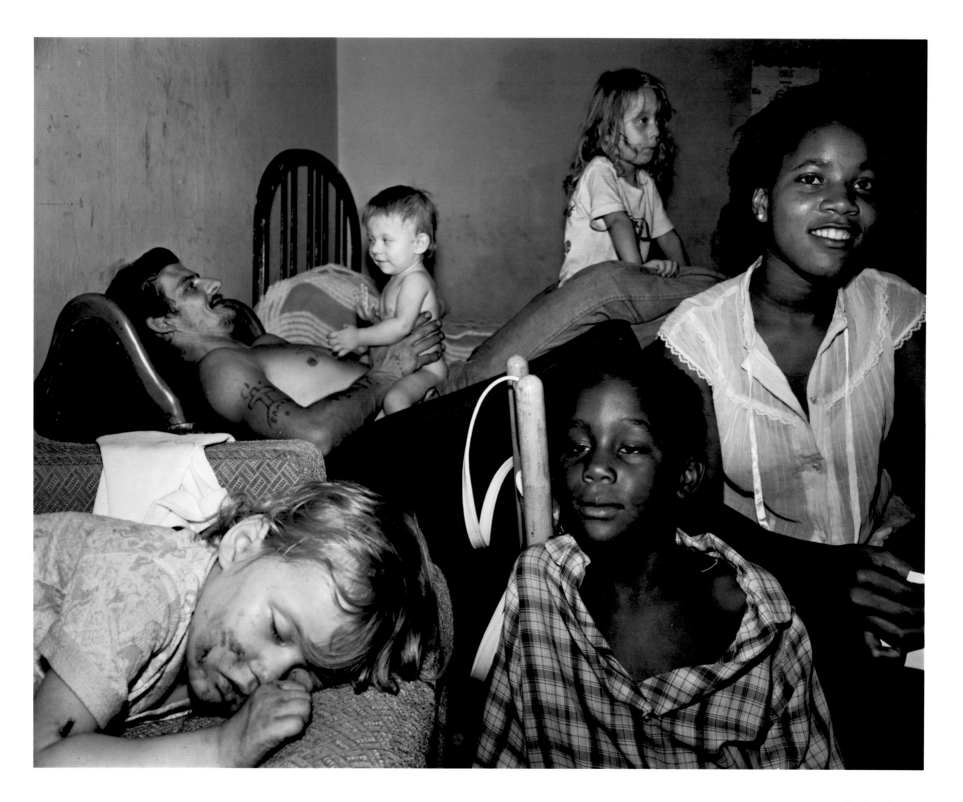

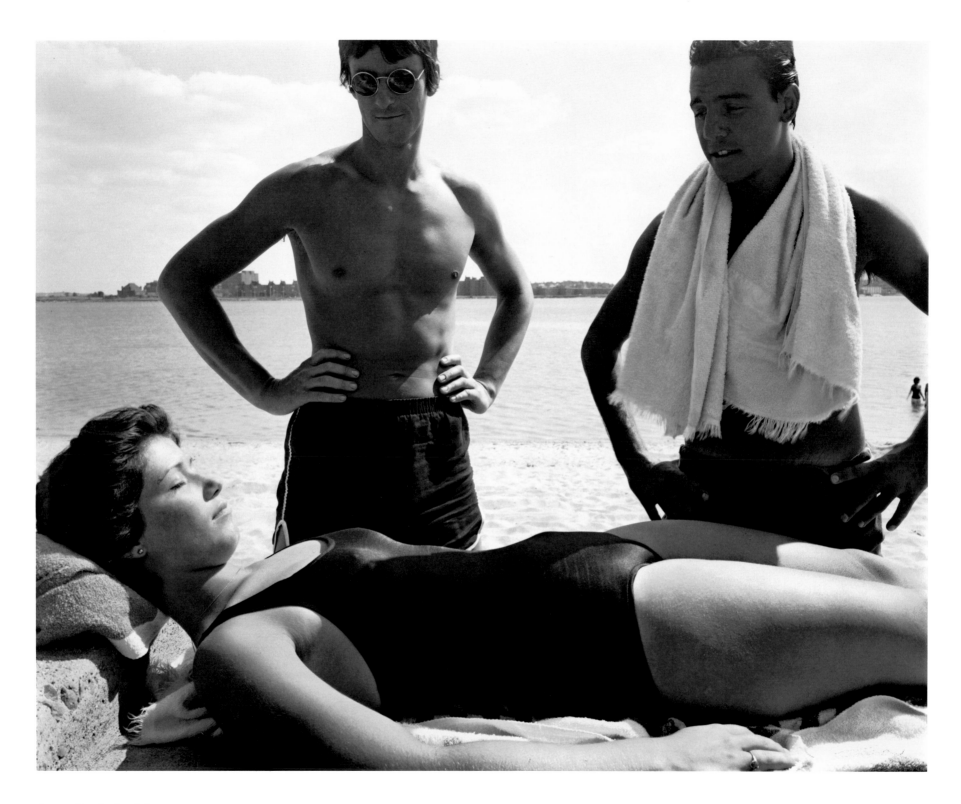

32 *Carson Beach, South Boston. 1978*

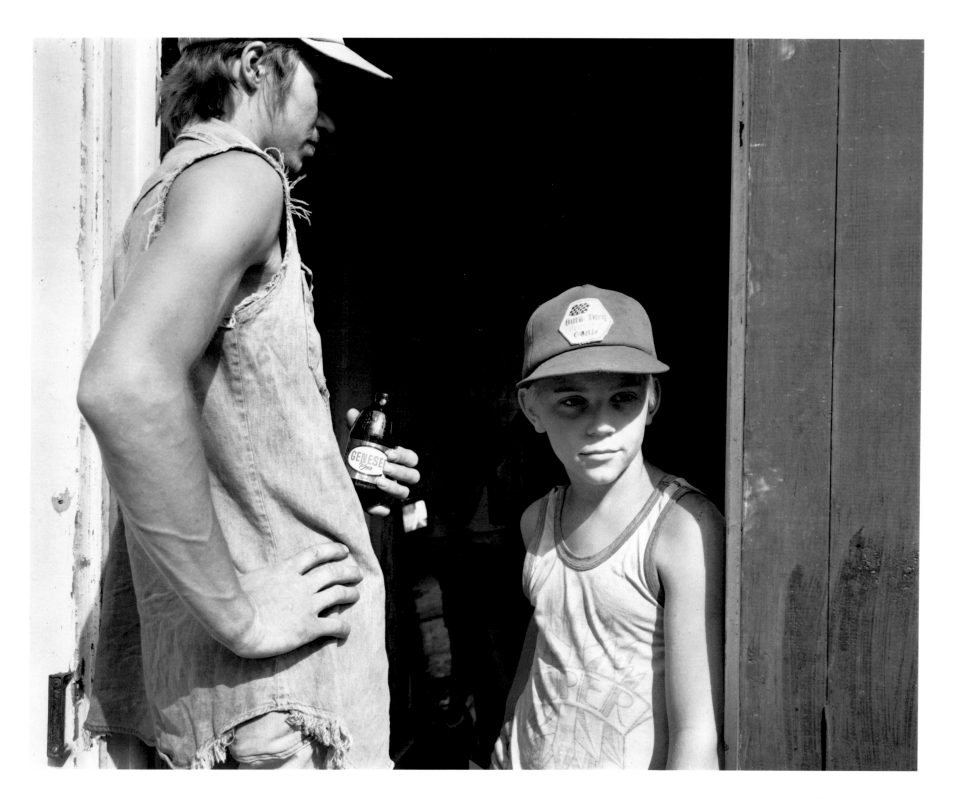

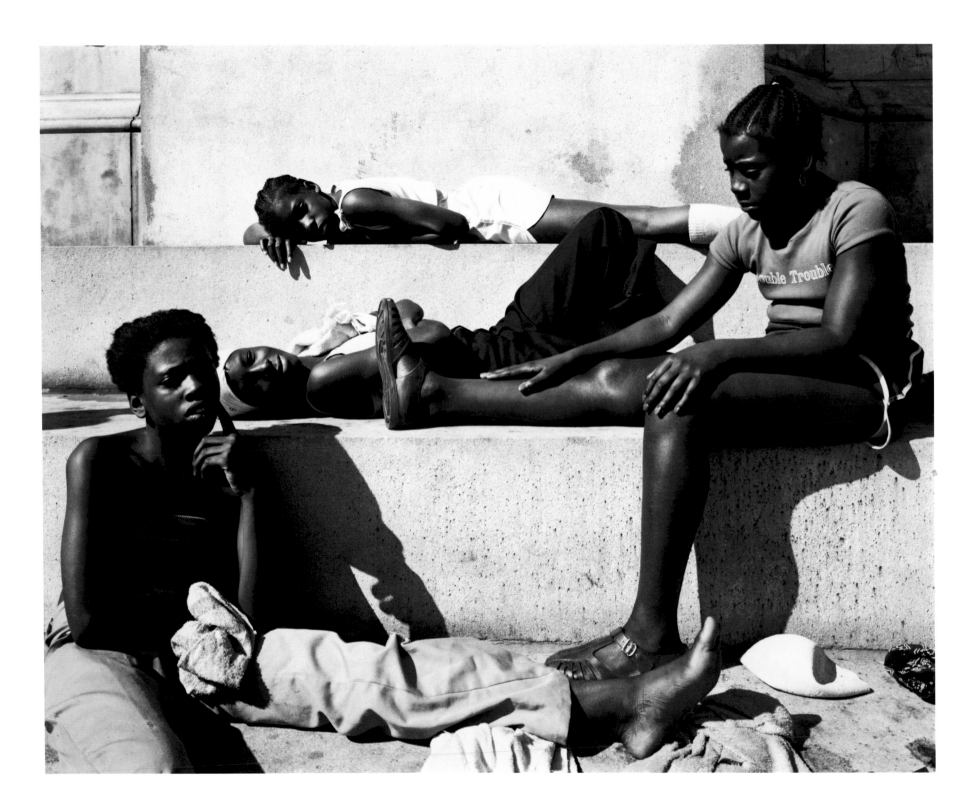

34 *Boston Common. 1978*

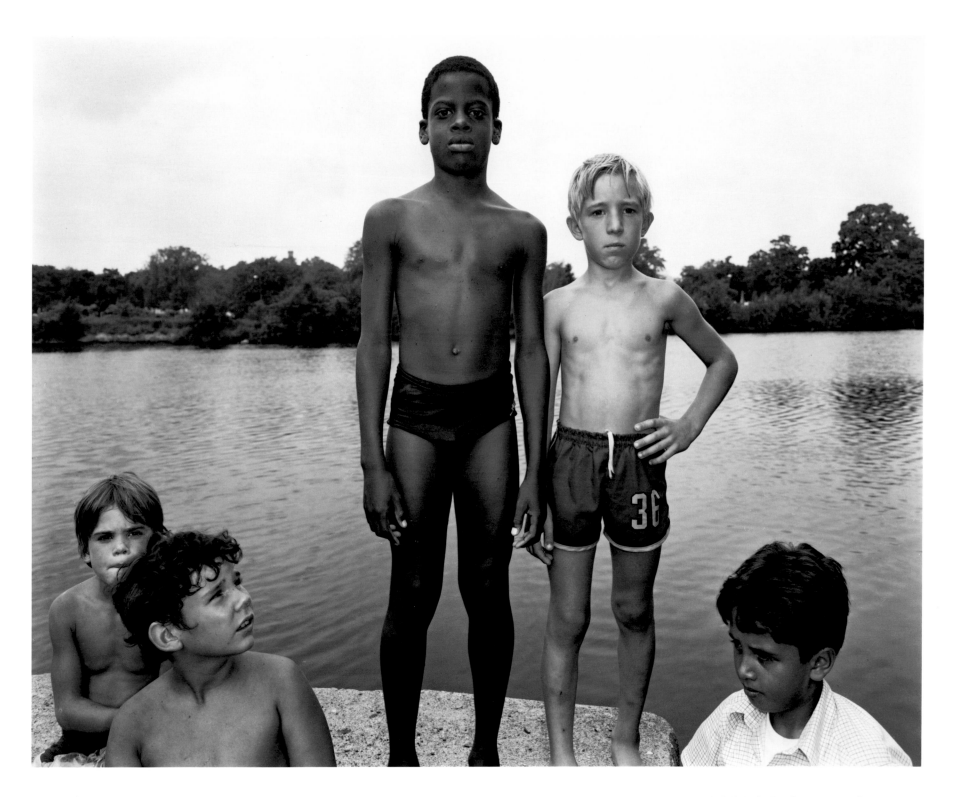

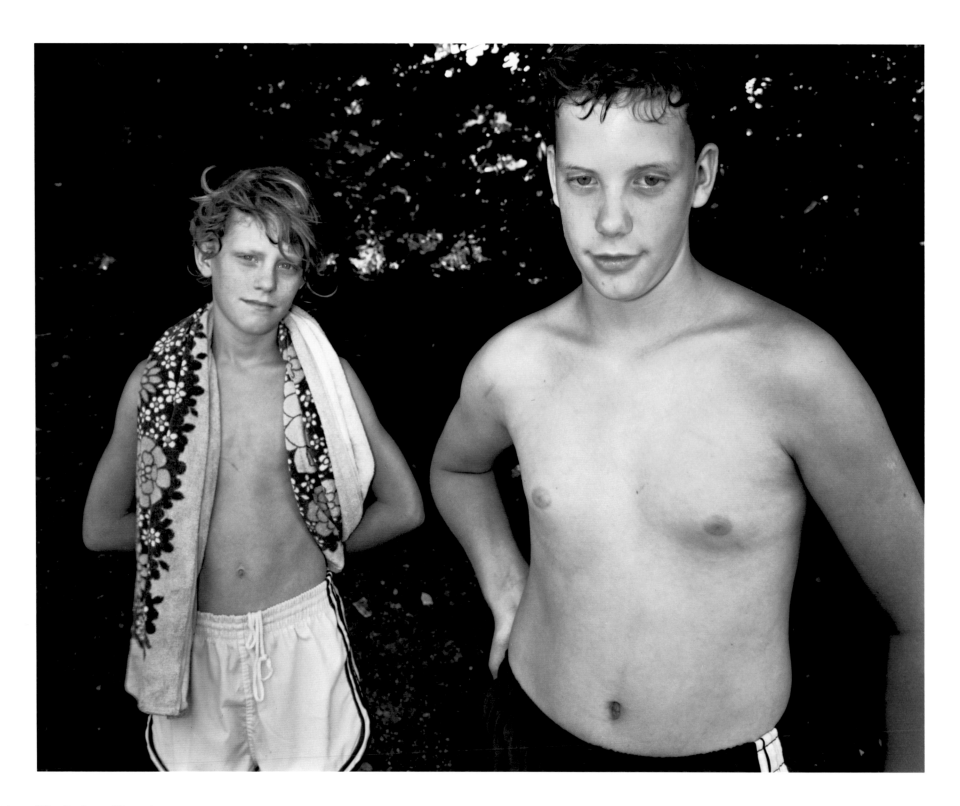

36 *West Roxbury, Massachusetts. 1979*

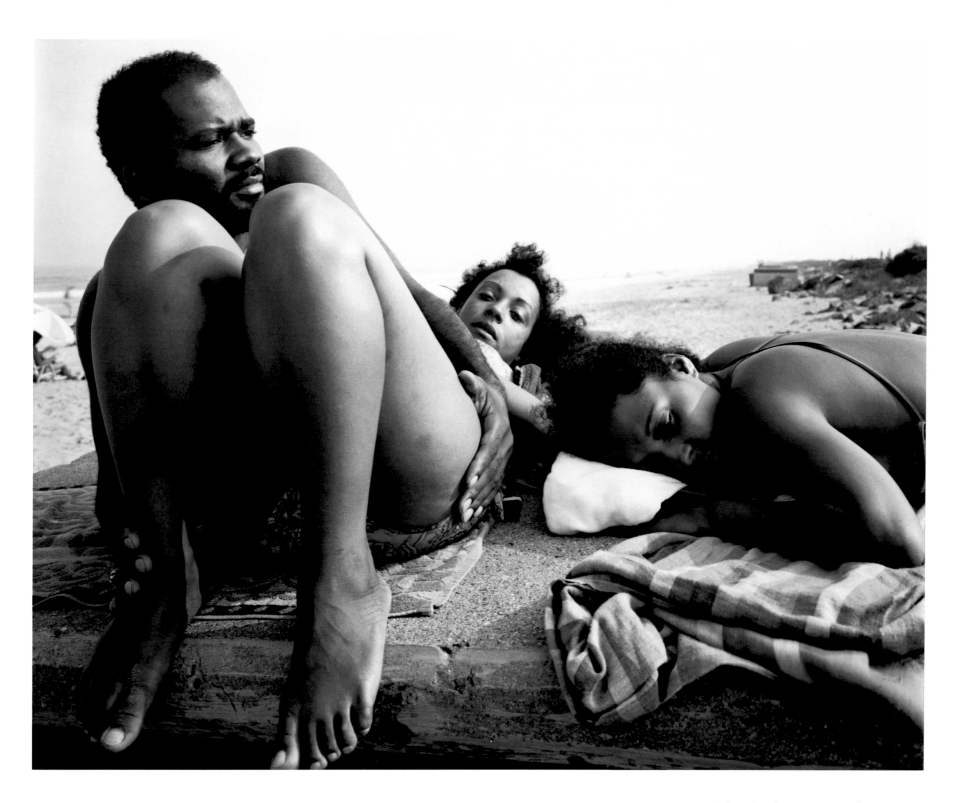

Nahant Beach, Lynn, Massachusetts. 1979 37

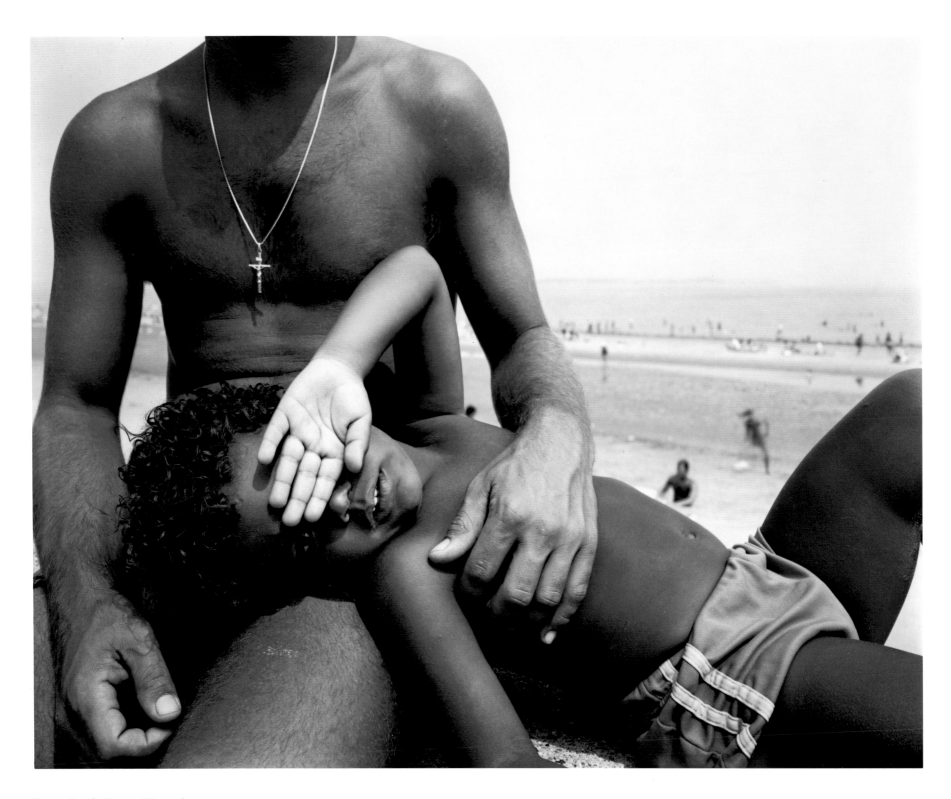

38 *Revere Beach, Revere, Massachusetts. 1980*

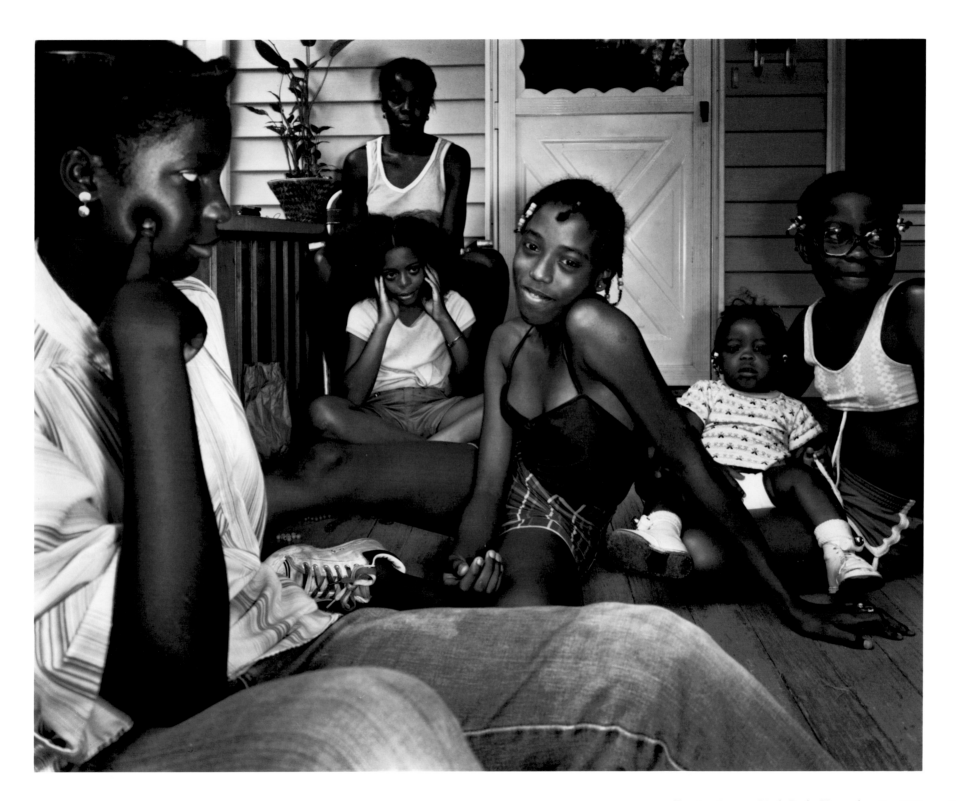

Taunton Avenue, Hyde Park, Massachusetts. 1979 39

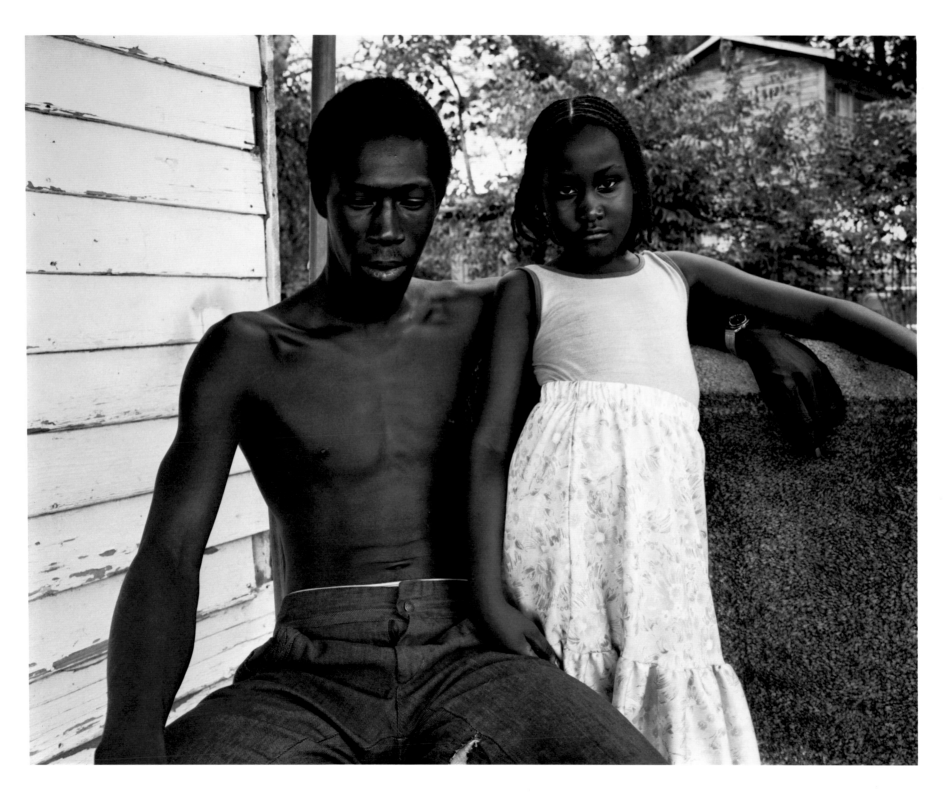

40 *Yazoo City, Mississippi. 1979*

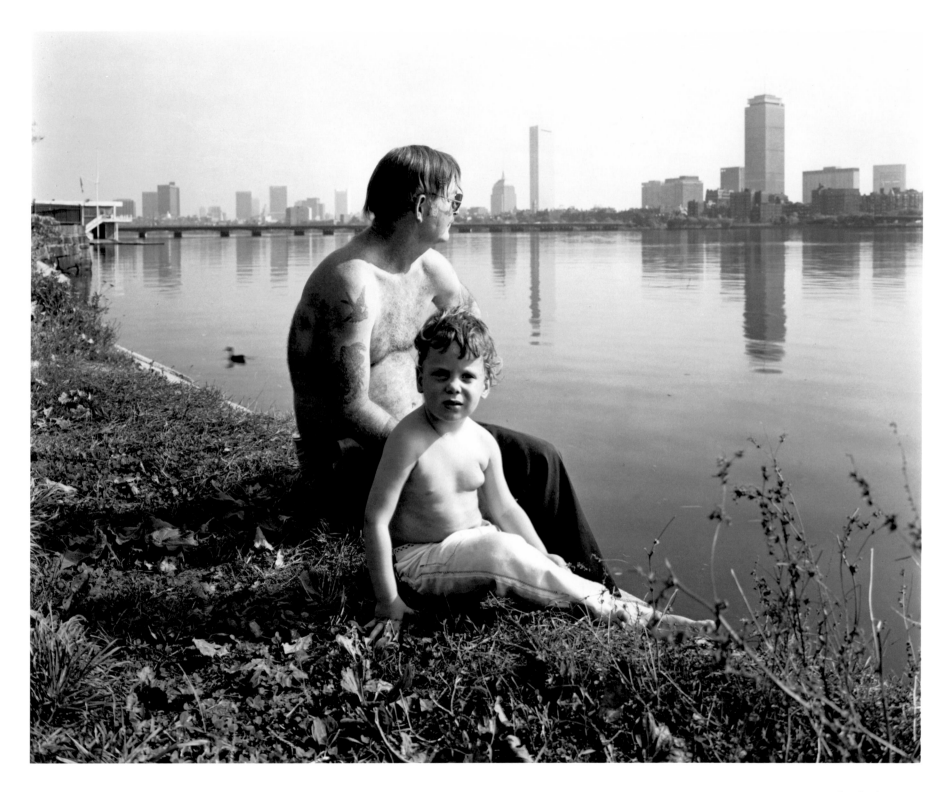

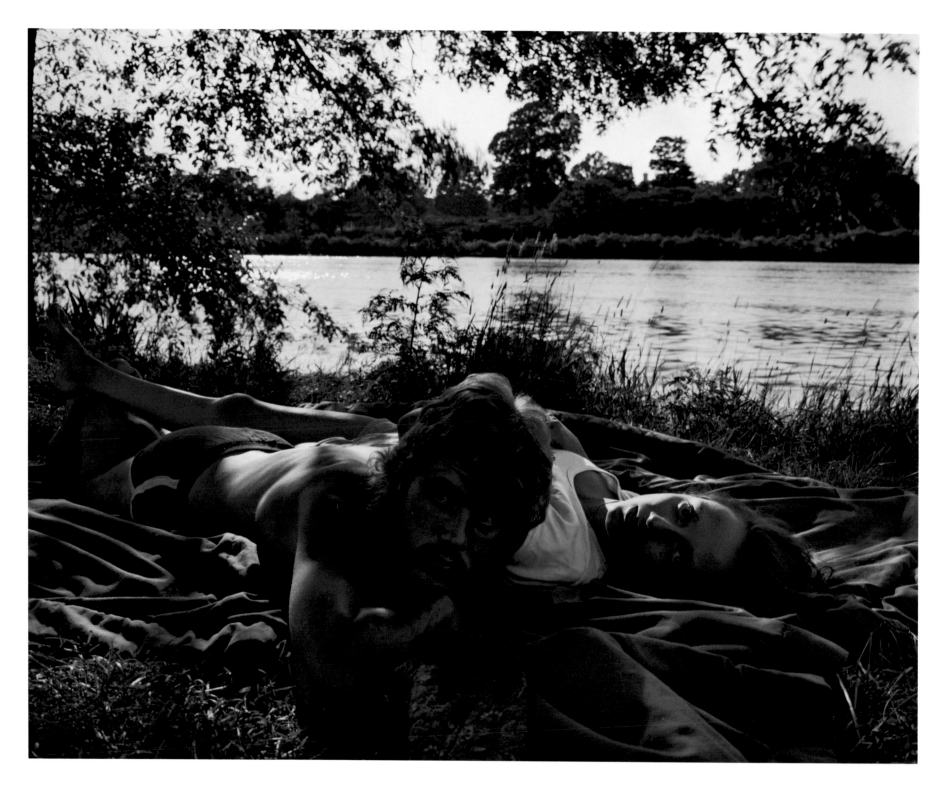

42 *Boston. 1980*

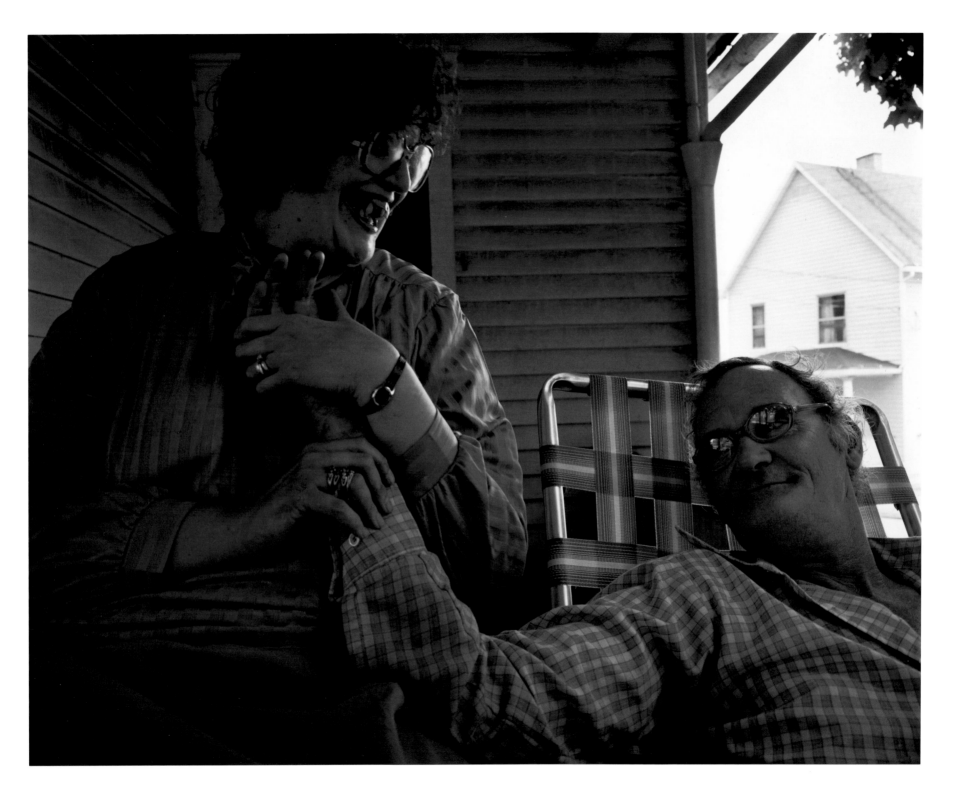

Sharon, Pennsylvania. 1980 43

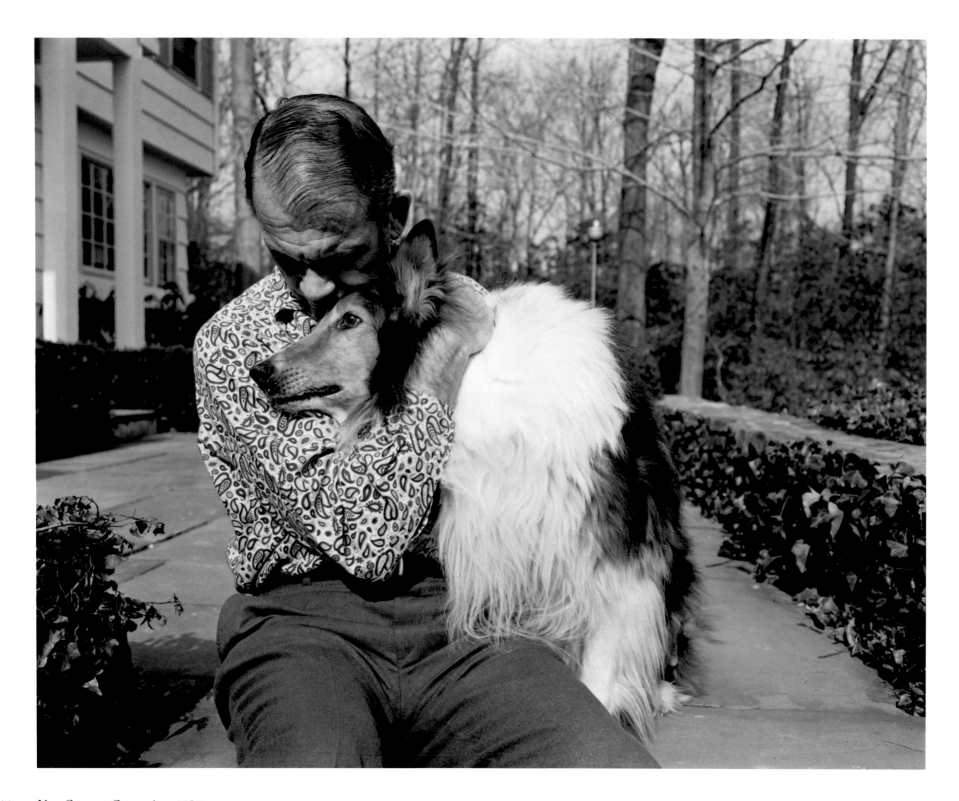

44 *New Canaan, Connecticut. 1980*

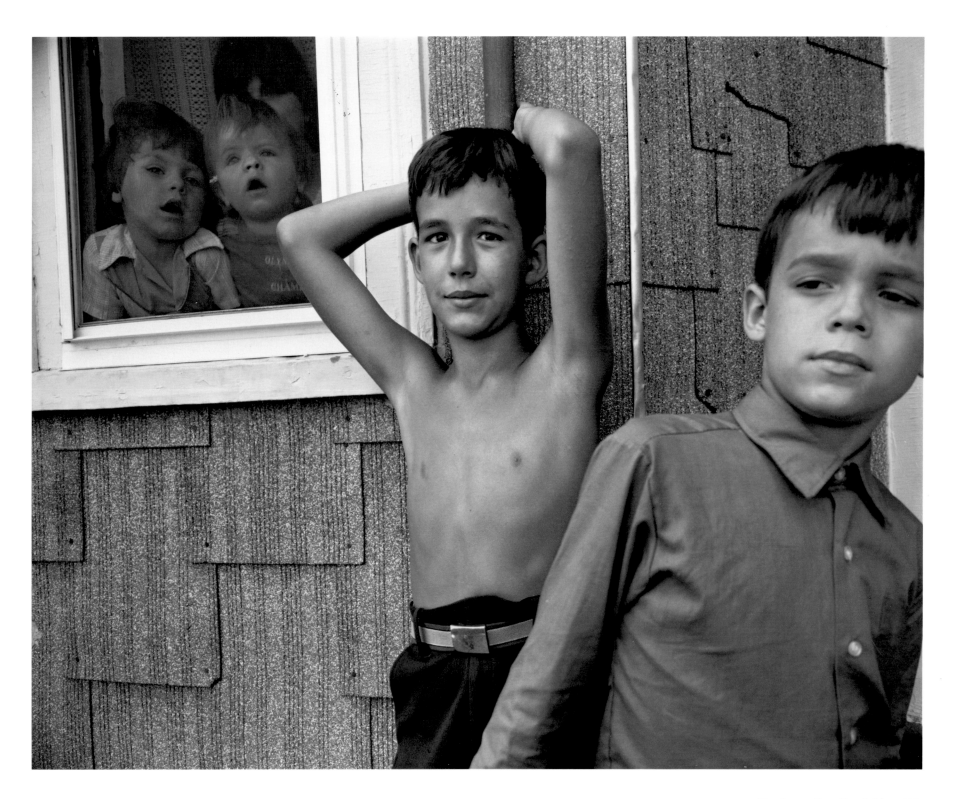

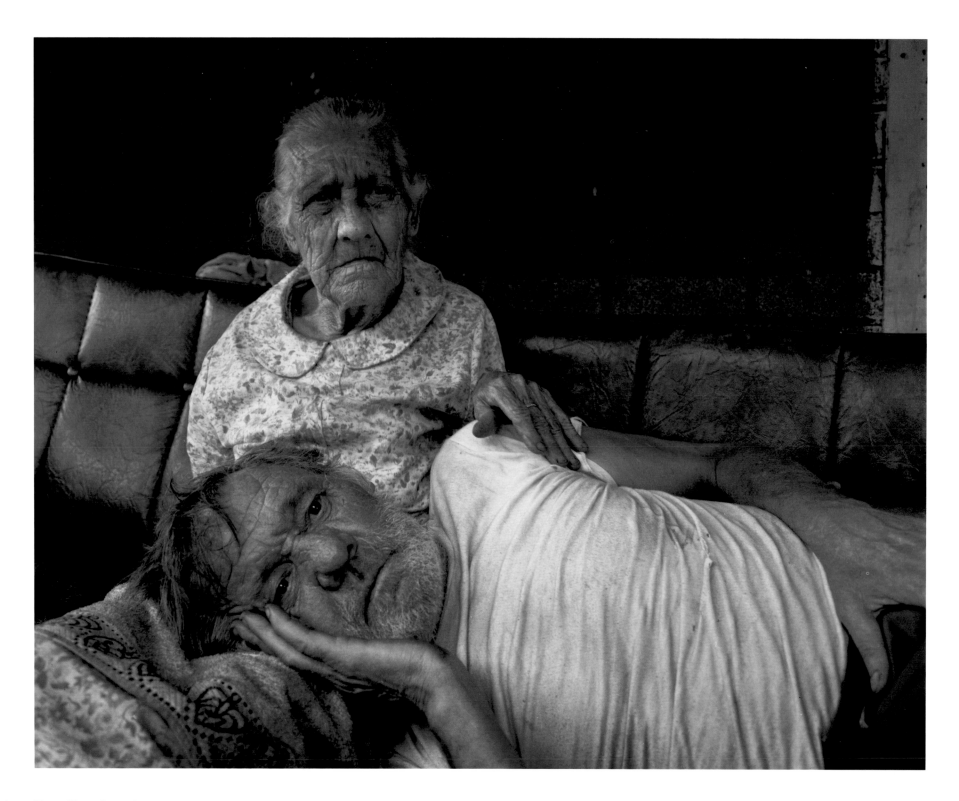

46 *Neon, Kentucky. 1982*

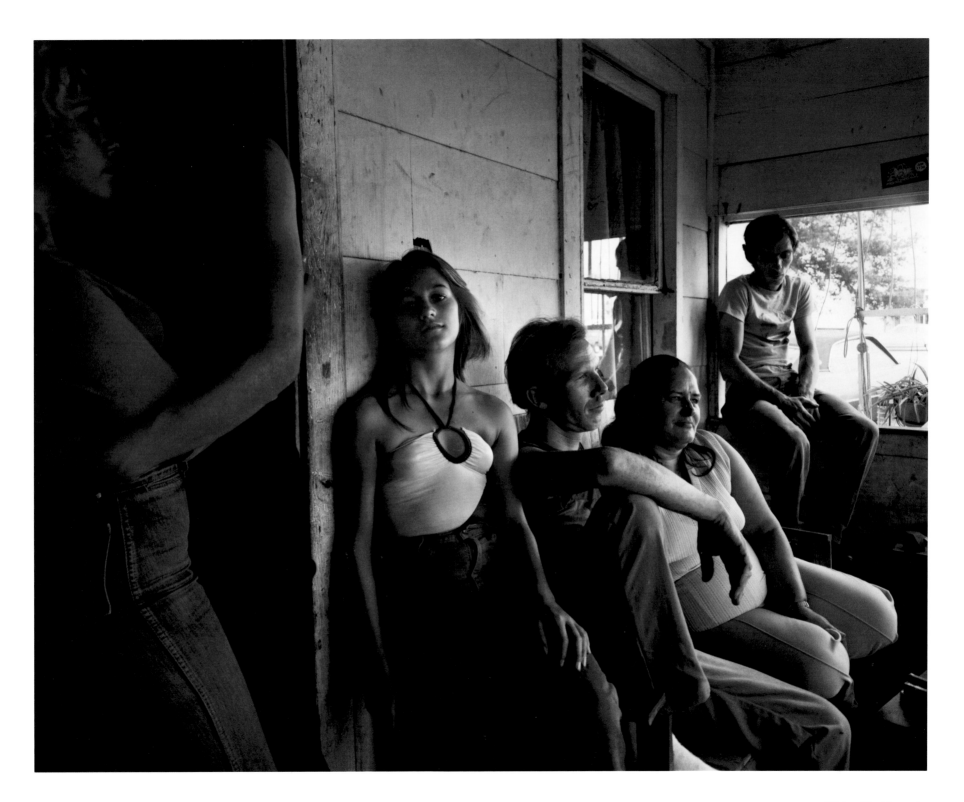

Eloise, Florida. 1982 47

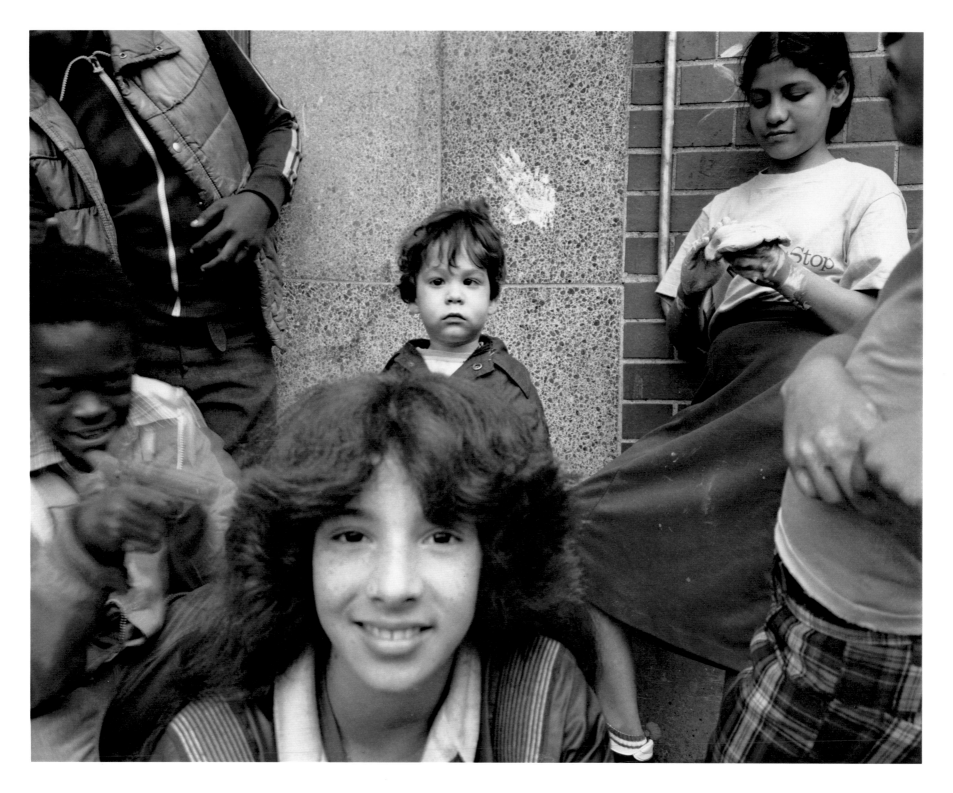

48 *Putnam Avenue, Cambridge. 1982*

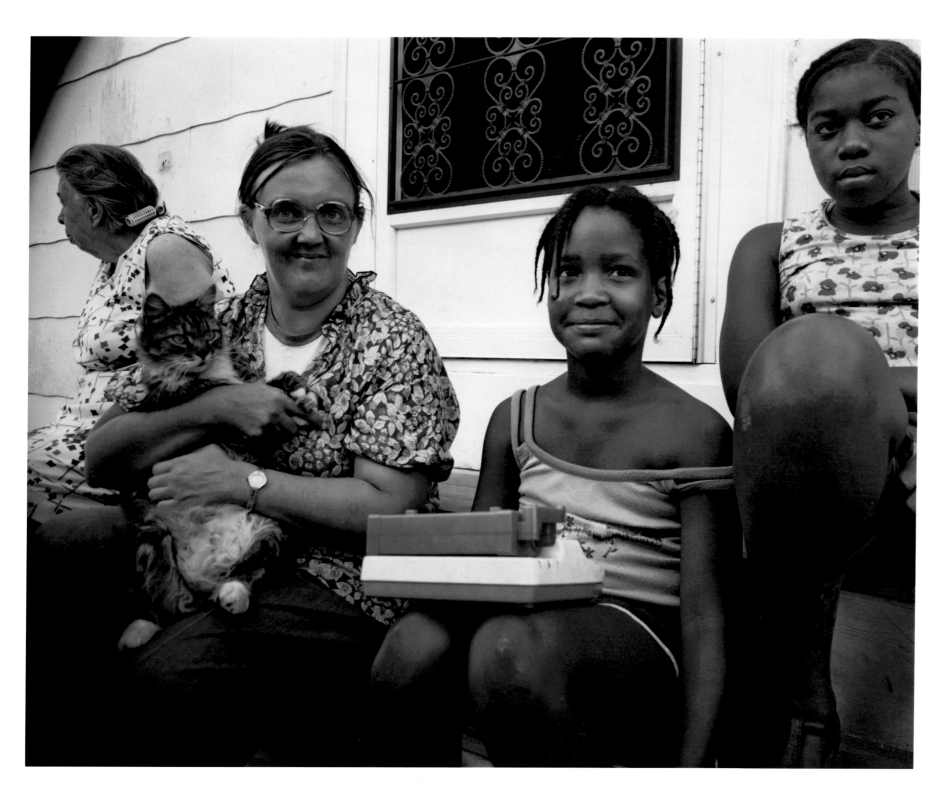

Kinnaird Street, Cambridge. 1981 49

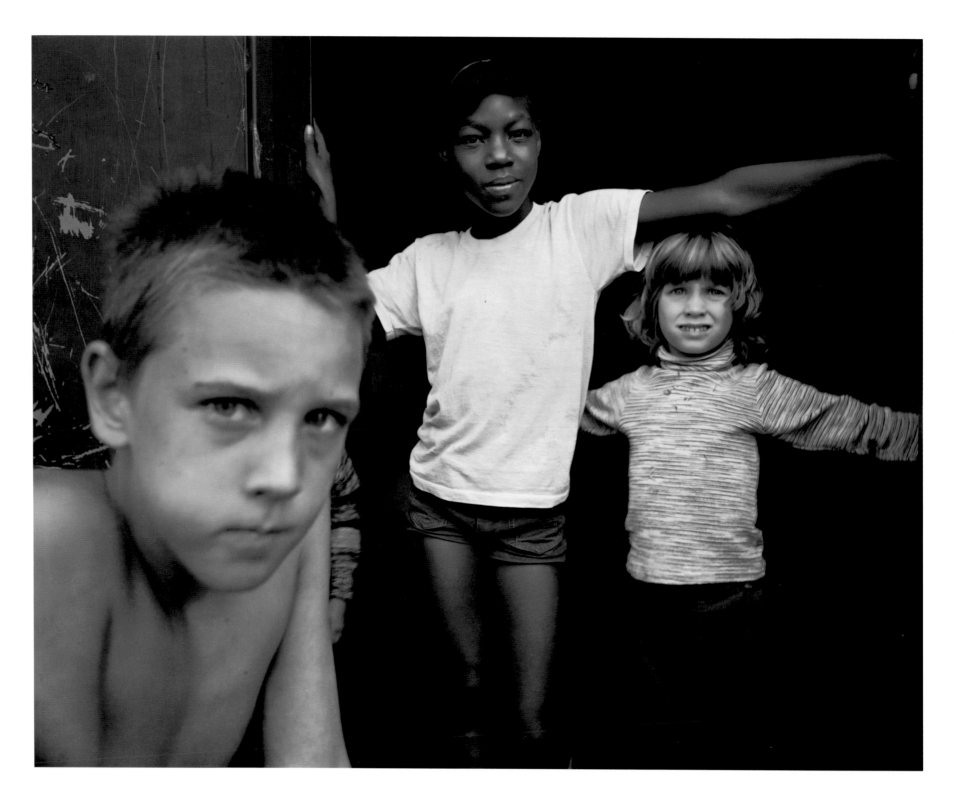

50 *Linden Street, East Cambridge. 1981*

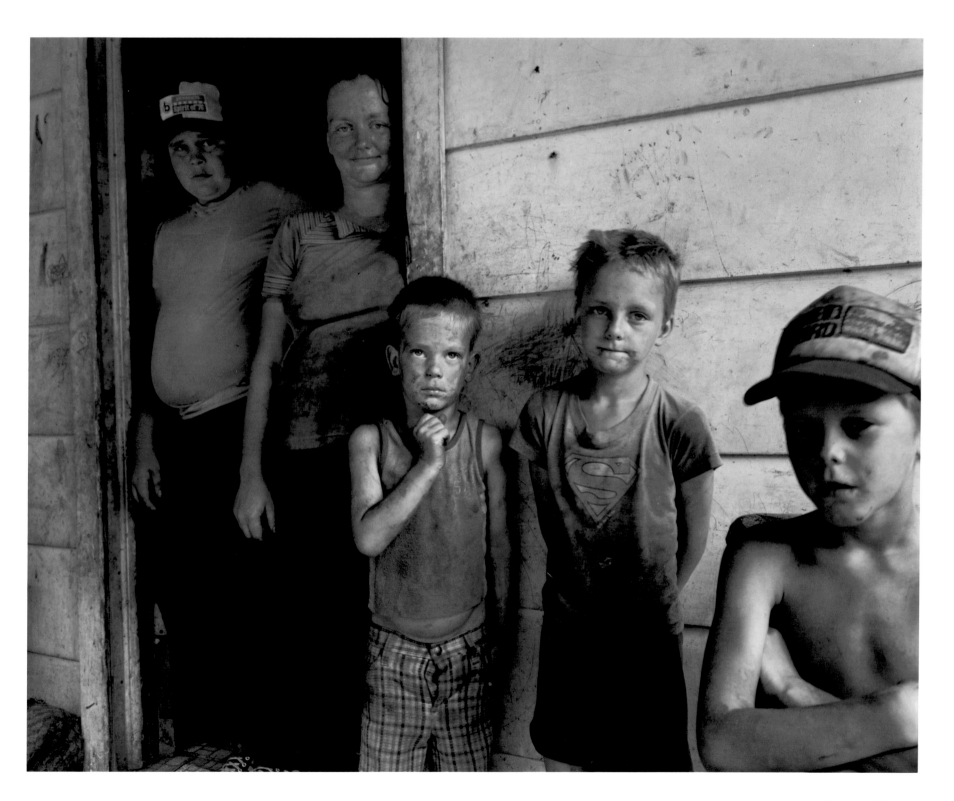

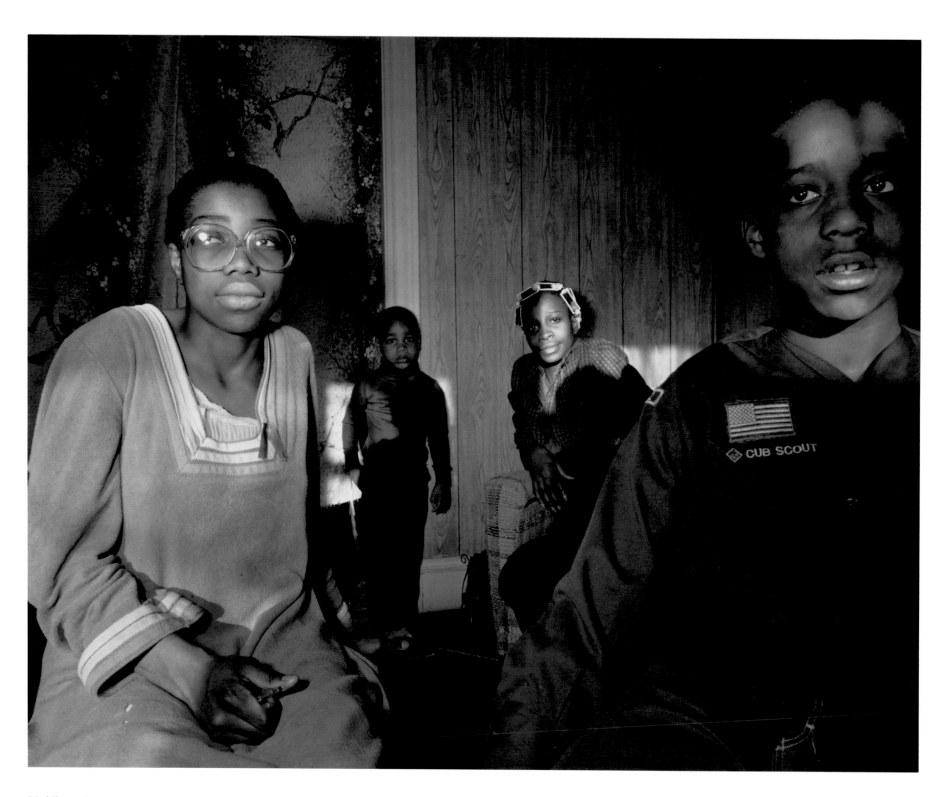

52 *Middleton Street, Dorchester, Massachusetts. 1981*

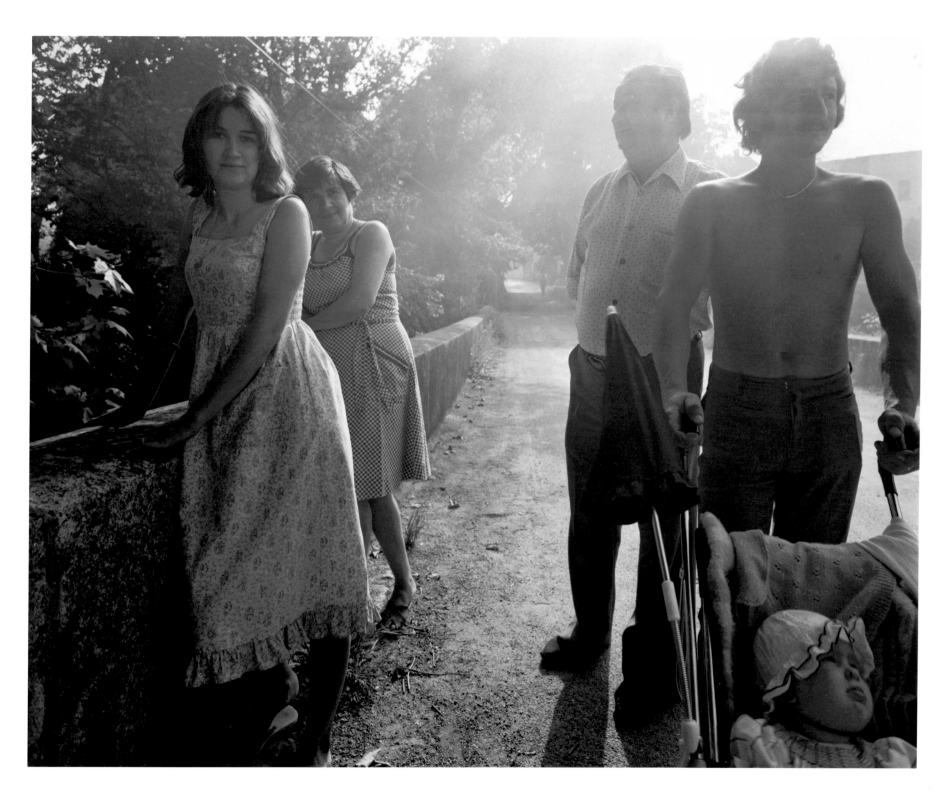

Besse, France. 1981 53

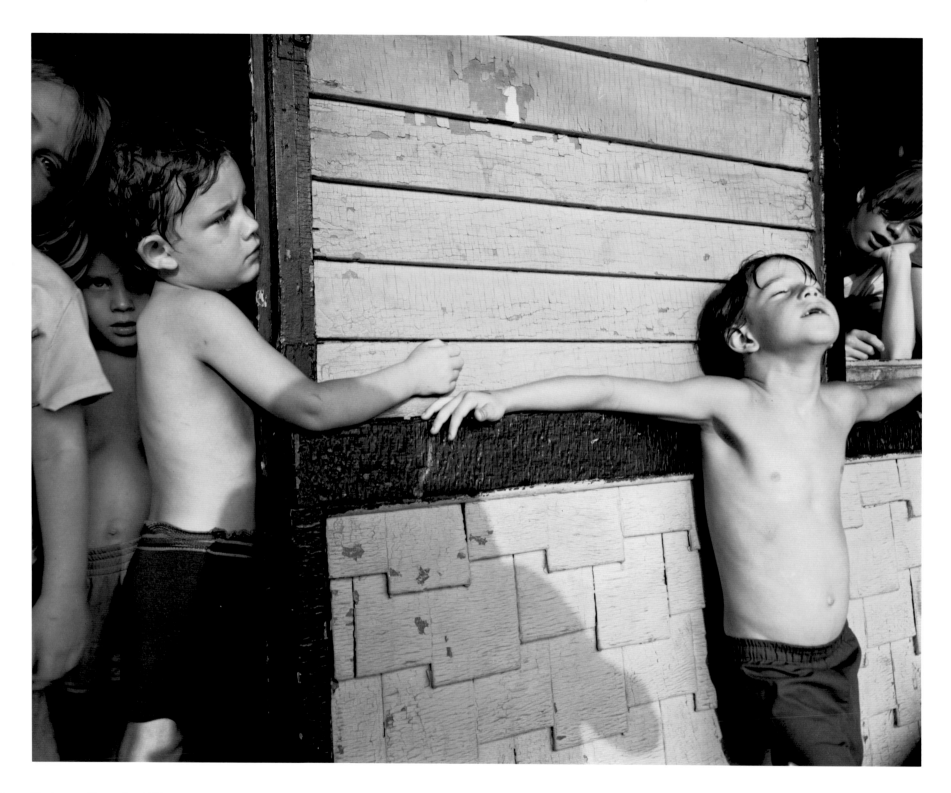

54 *Covington, Kentucky. 1982*

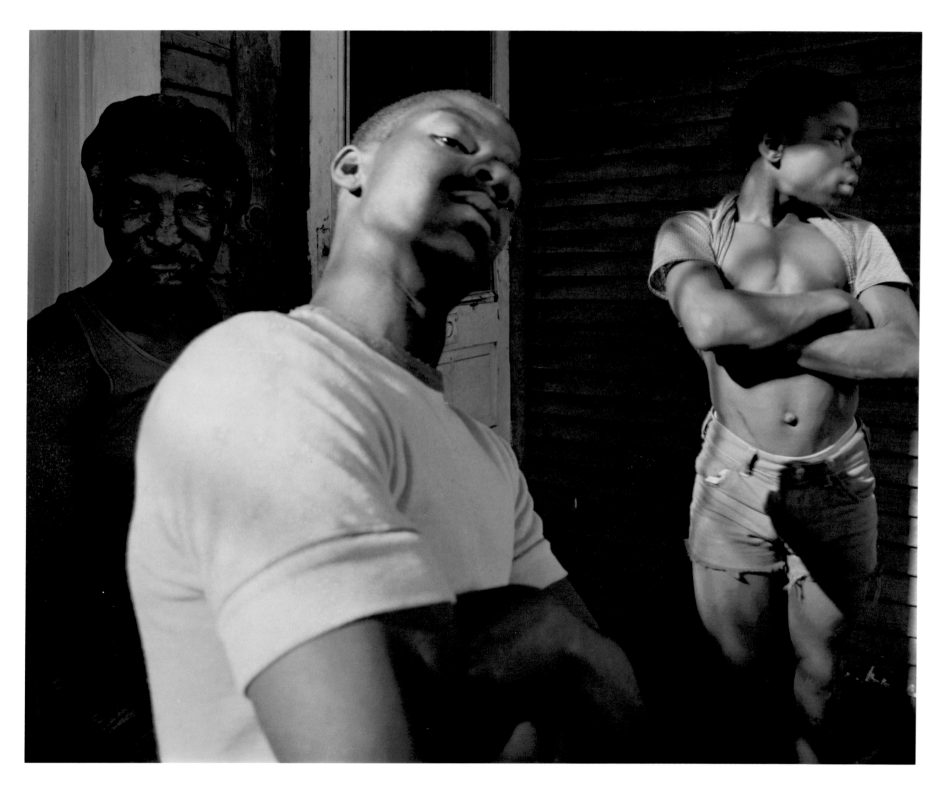

West Canfield Avenue, Detroit. 1982 55

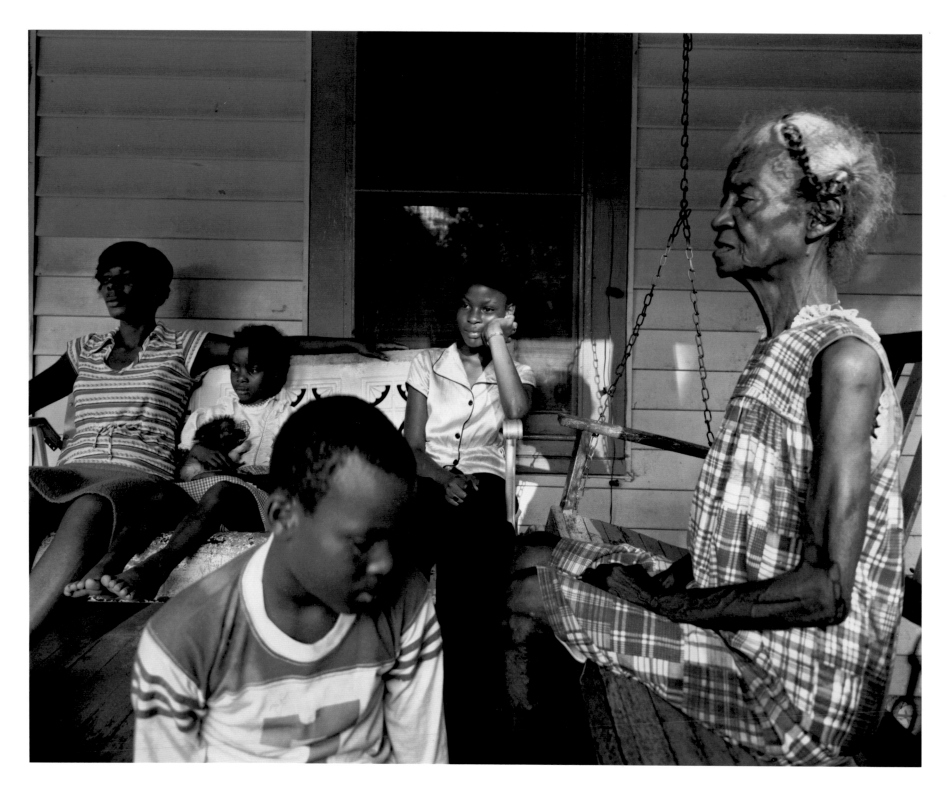

56 *Emma Street, Lakeland, Florida. 1982*

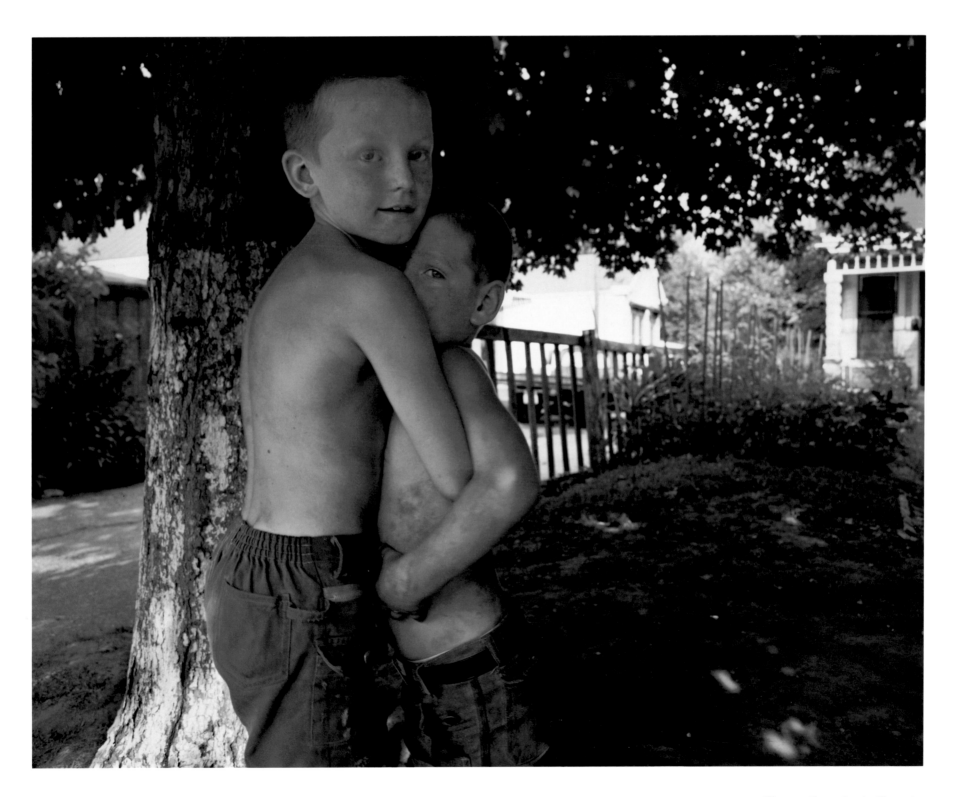

Old People

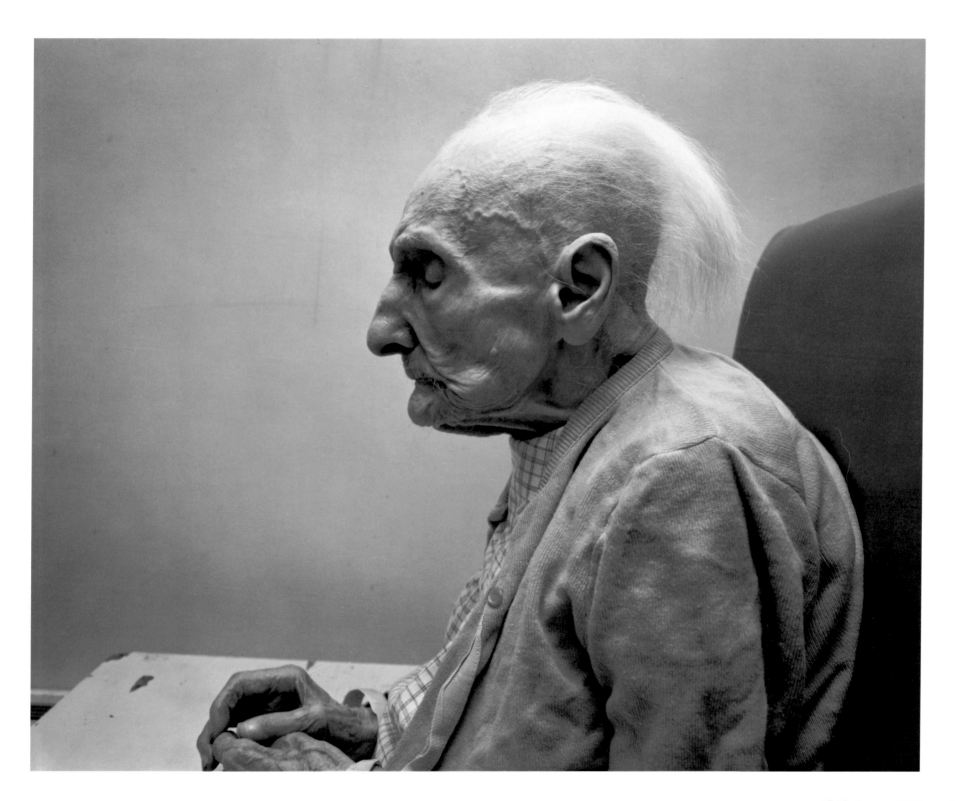

C. C., Boston. 1983 59

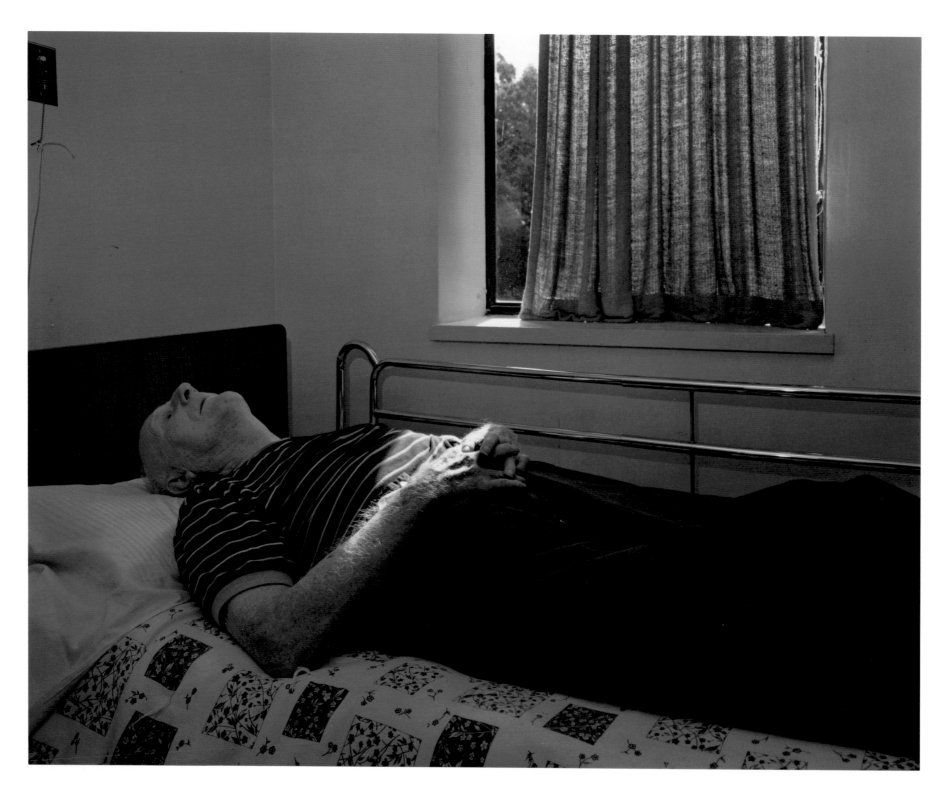

60 *C. M., Boston. 1984*

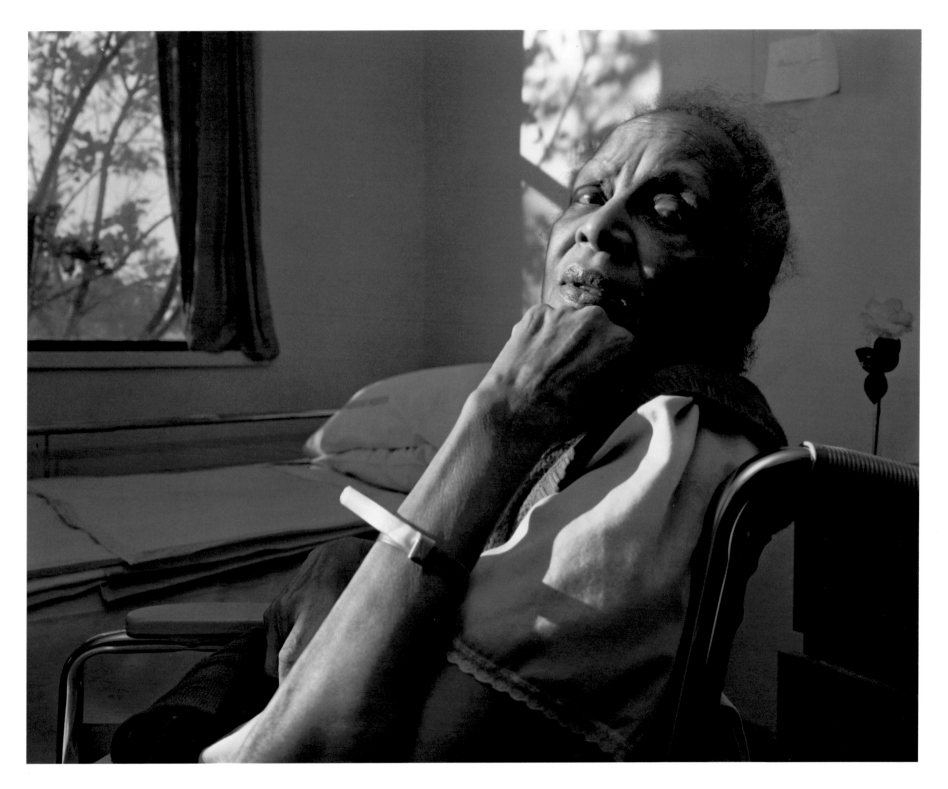

J. M., Boston. 1983 61

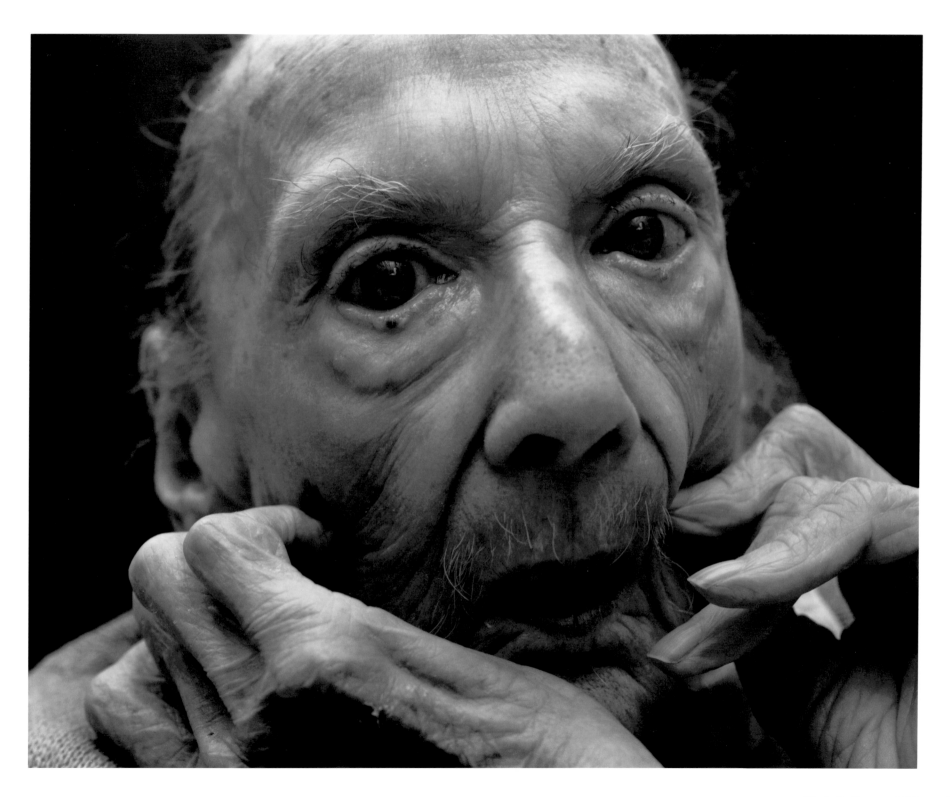

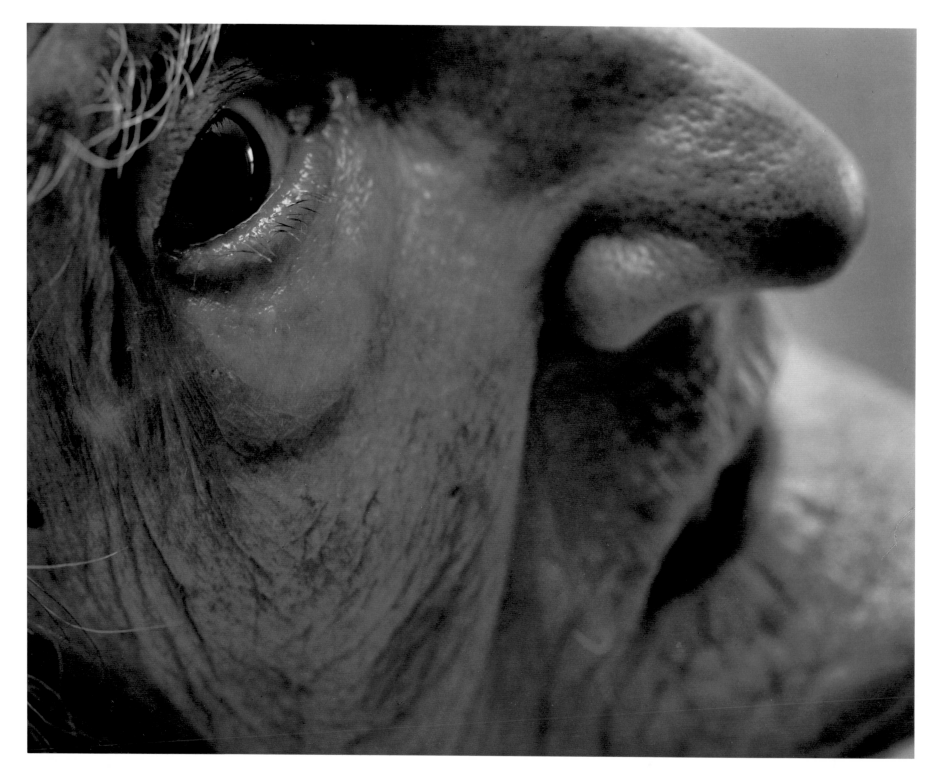

64 *A. K., Boston. 1985*

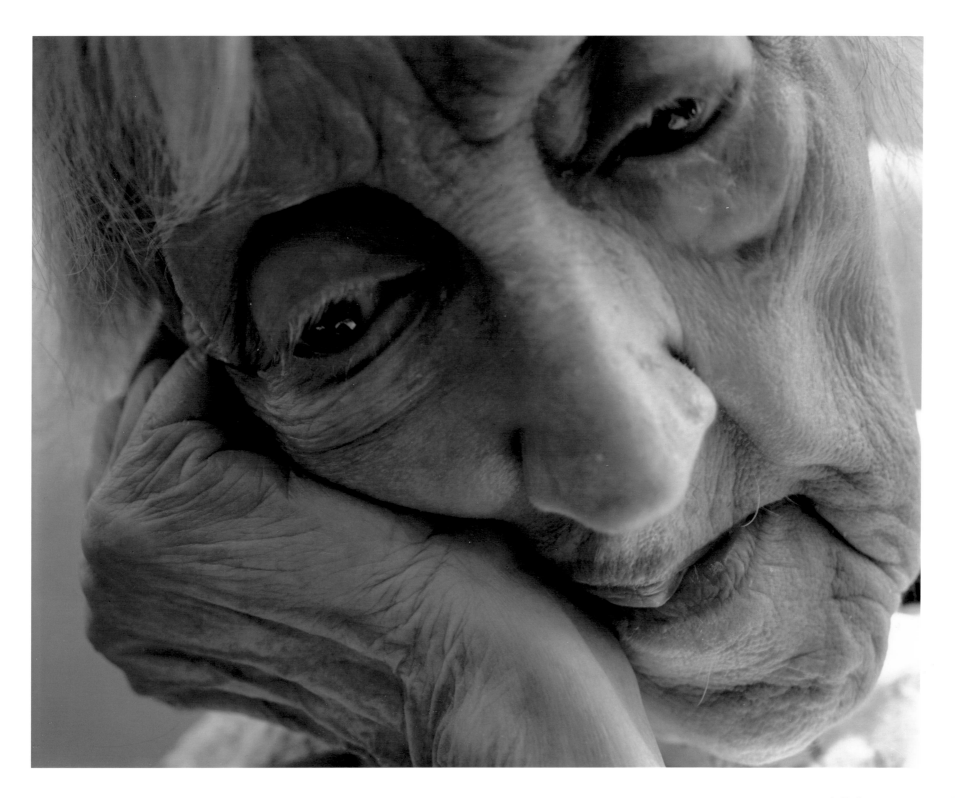

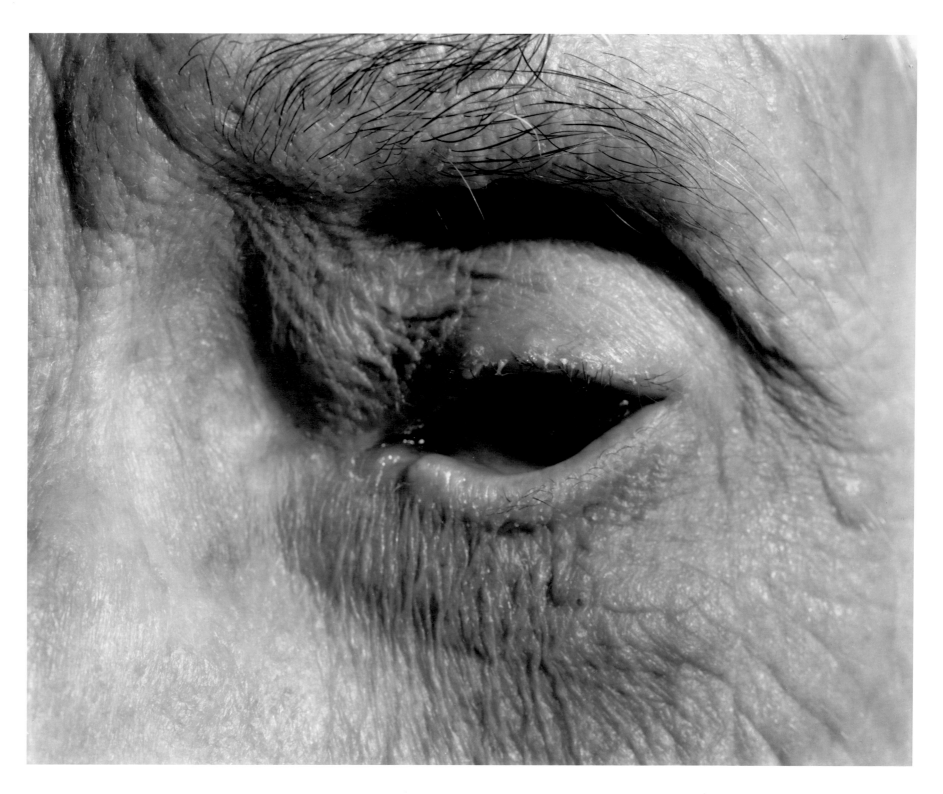

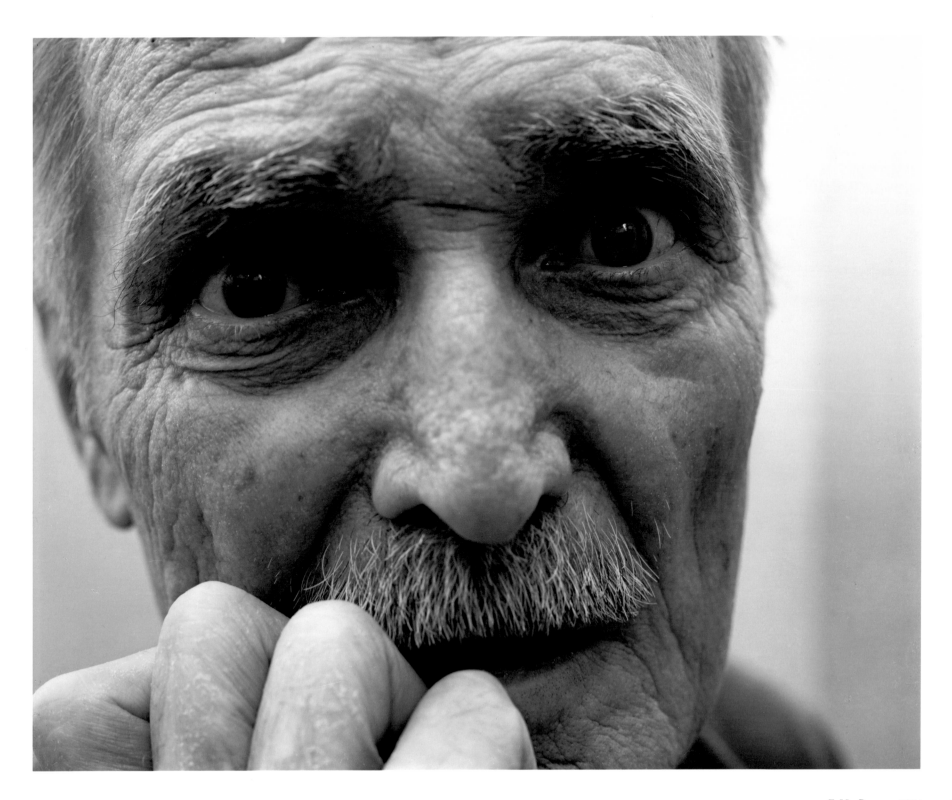

F. H., Boston. 1984 69

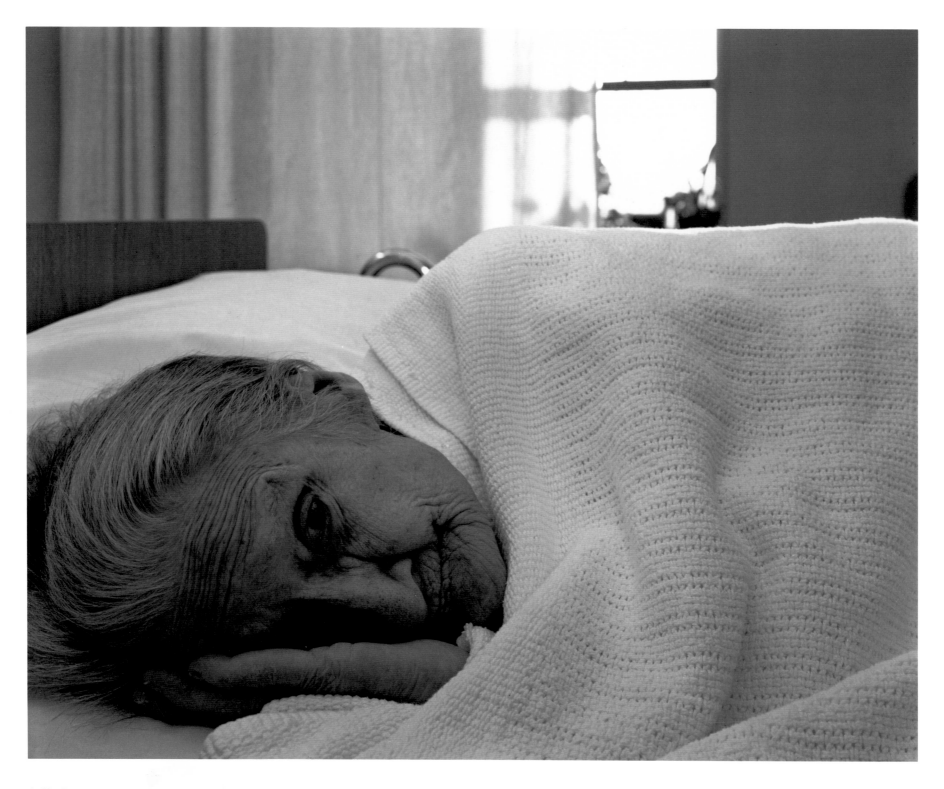

70 *A. K., Boston. 1985*

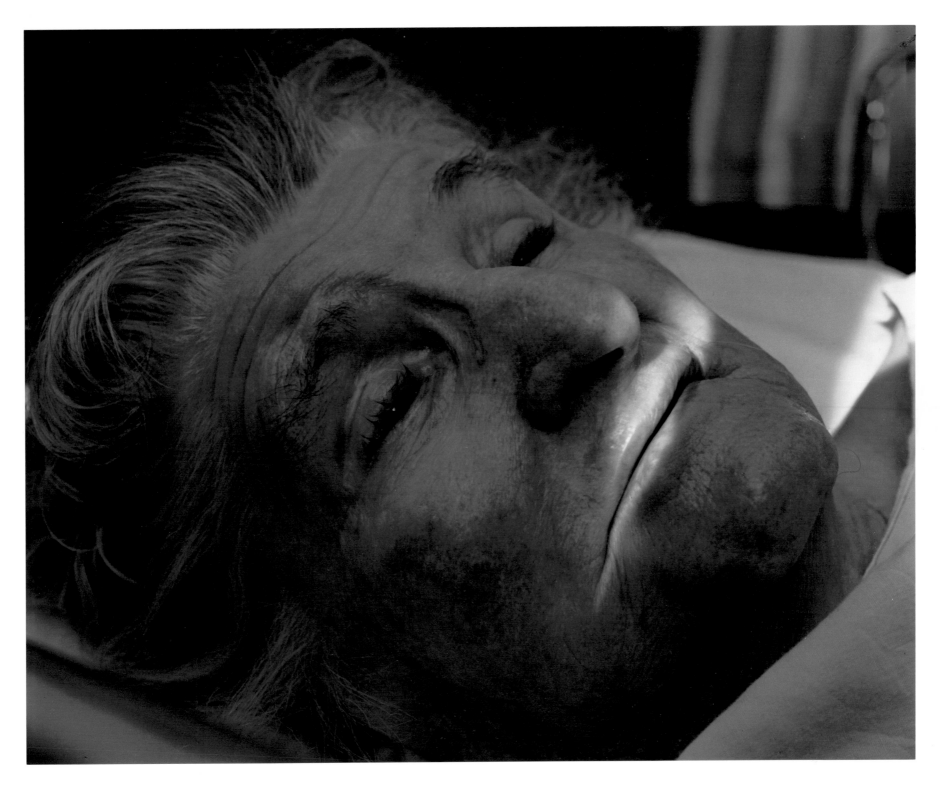

M. H., Boston. 1984 71

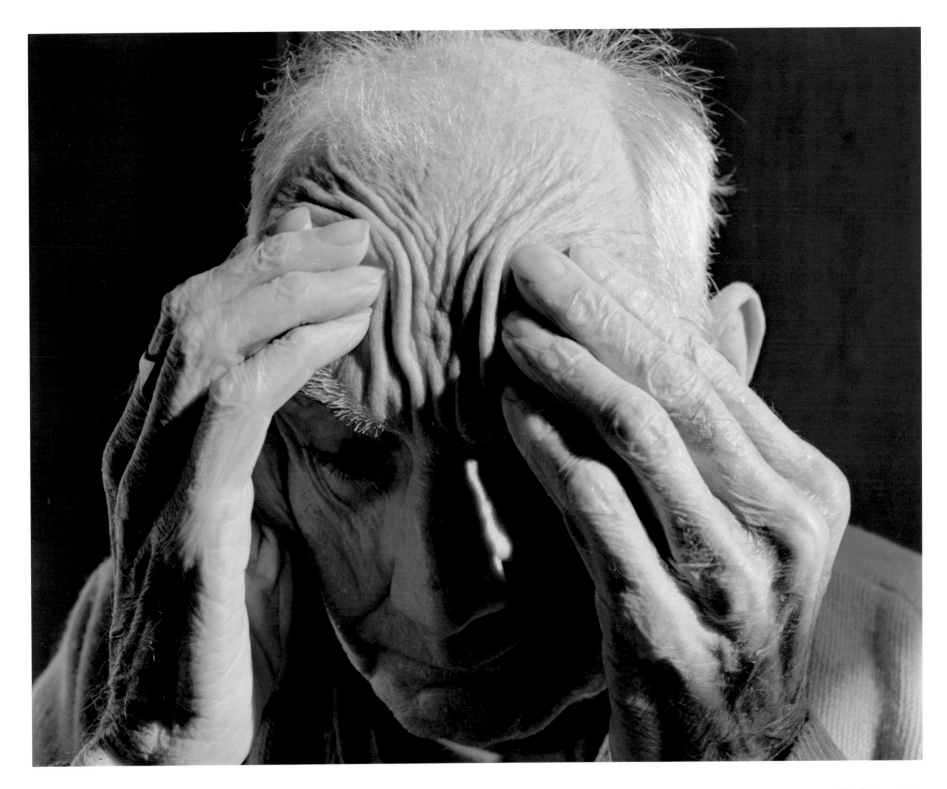

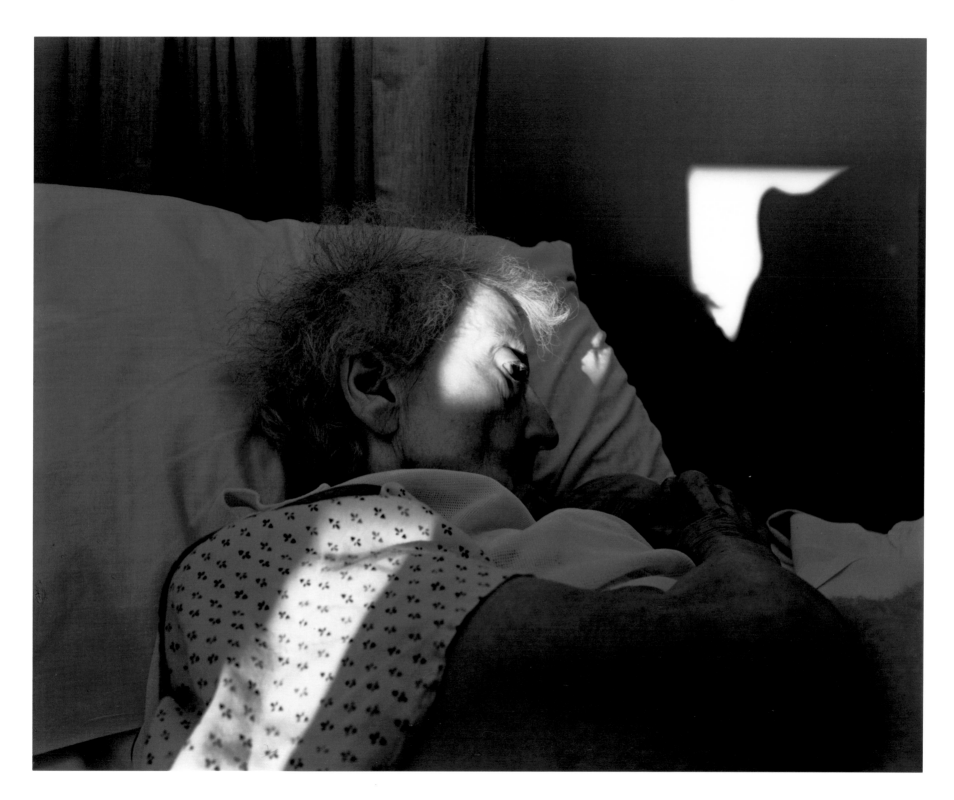

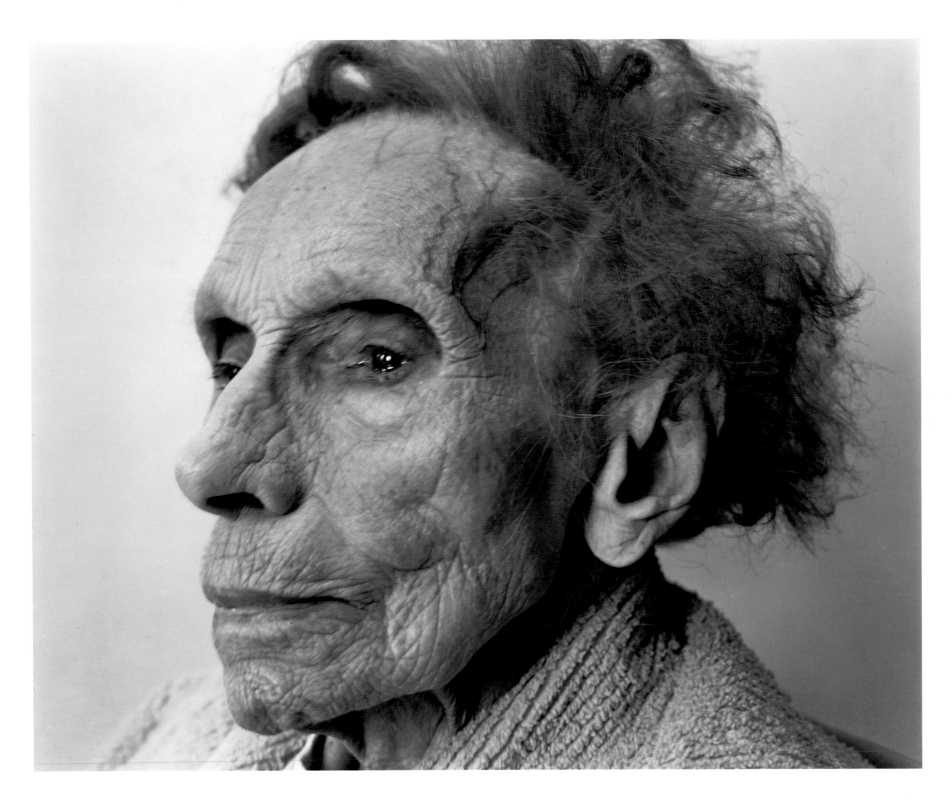

76 *A. I., Boston. 1985*

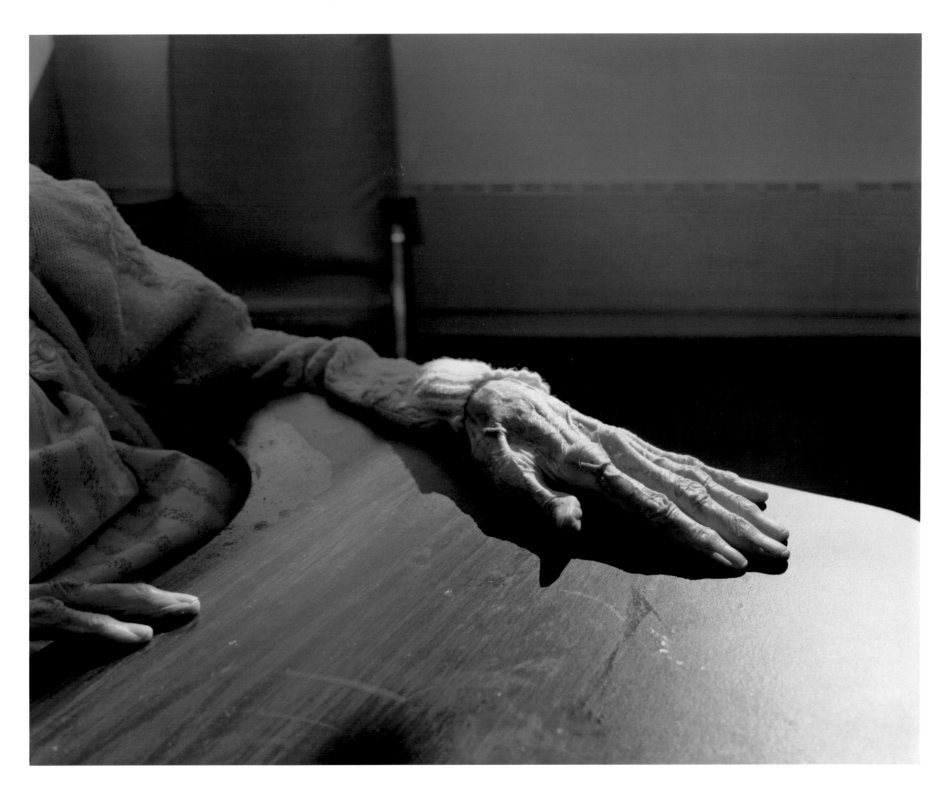

At Home

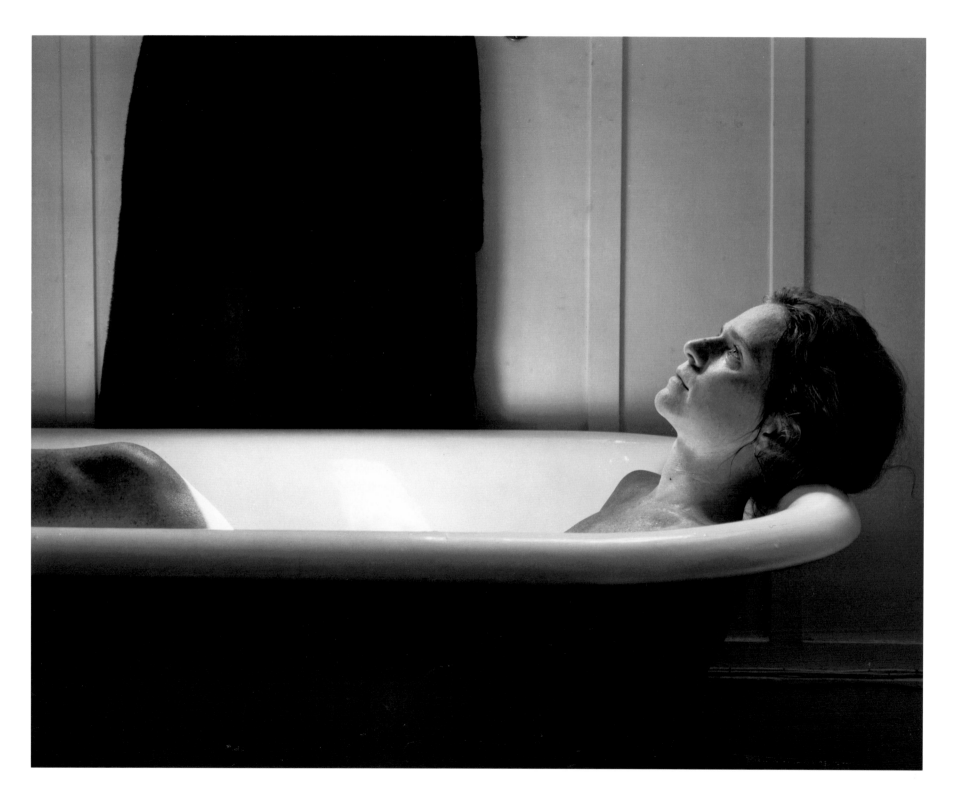

Bebe, Cambridge. 1980 79

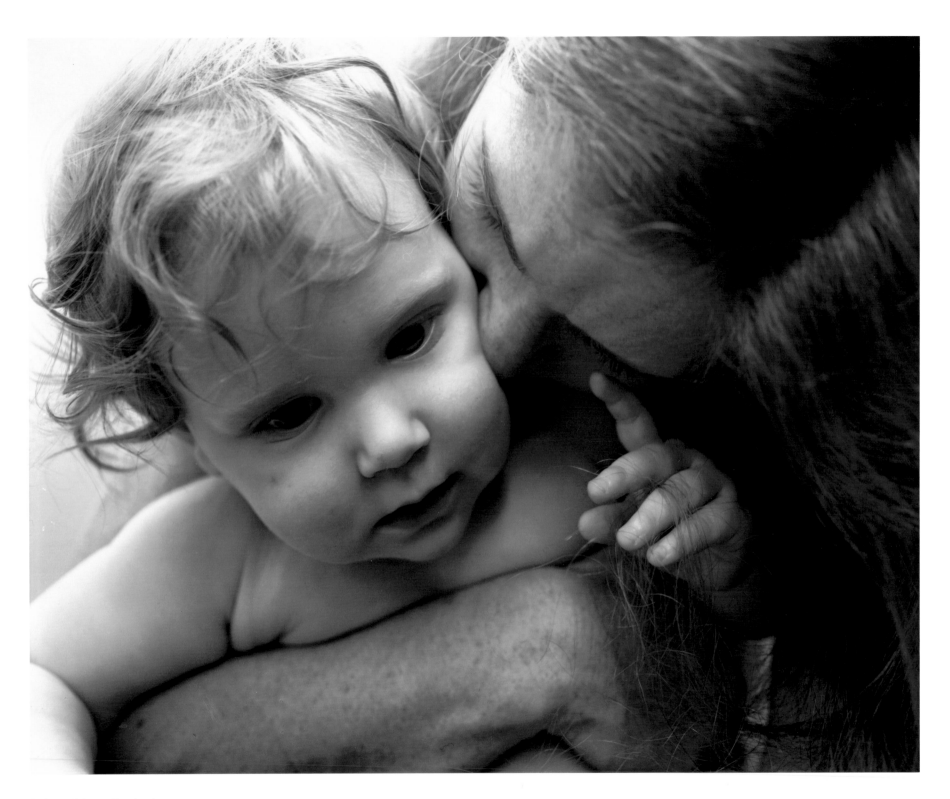

80 *Bebe and Sam, Cambridge. 1984*

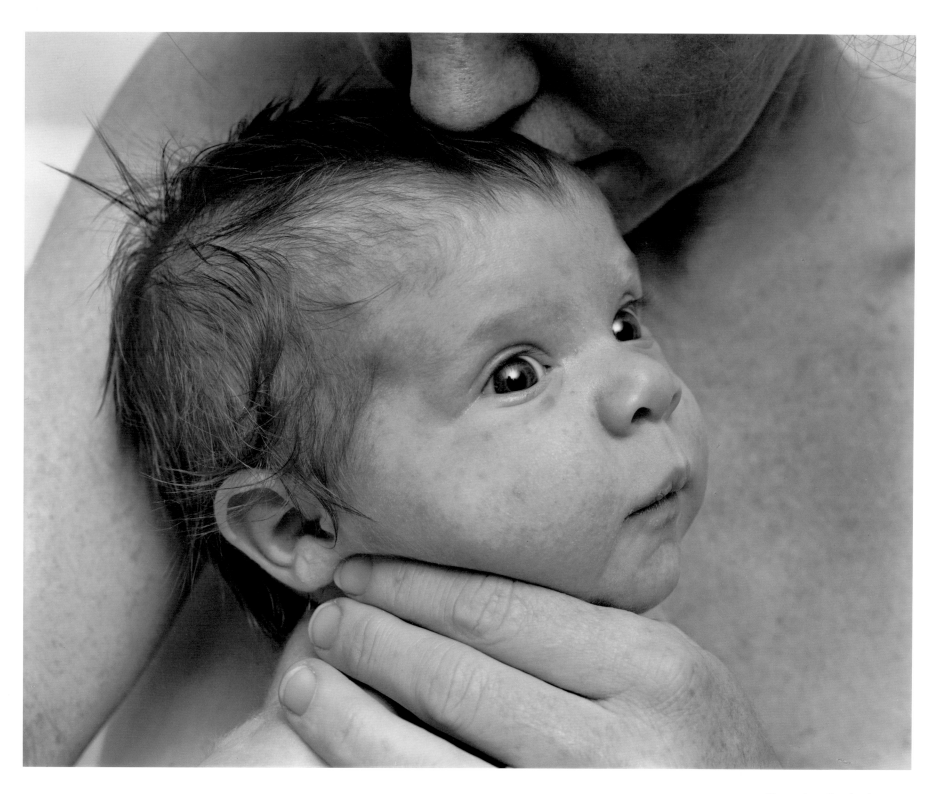

Clementine, Cambridge. 1985 81

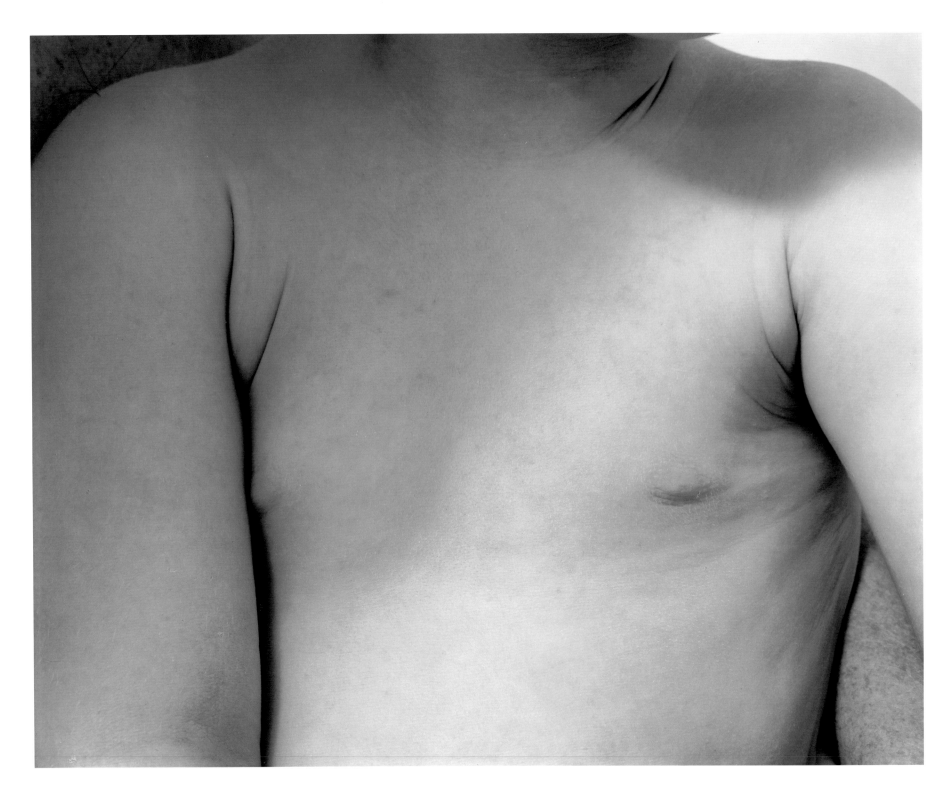

82 *Cambridge. 1986*

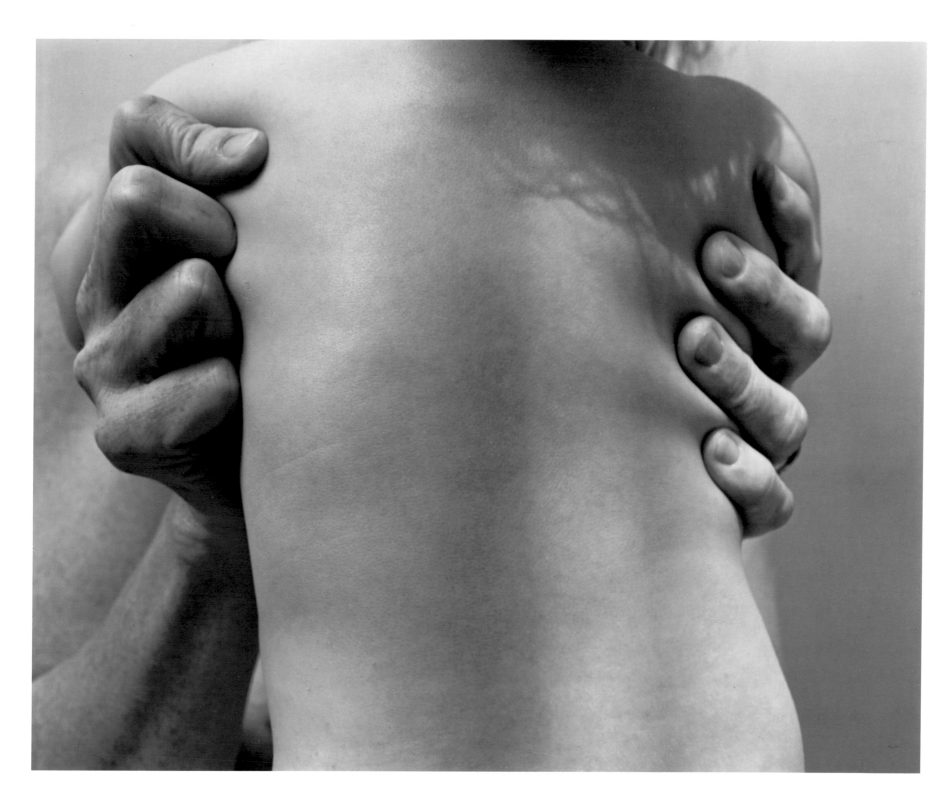

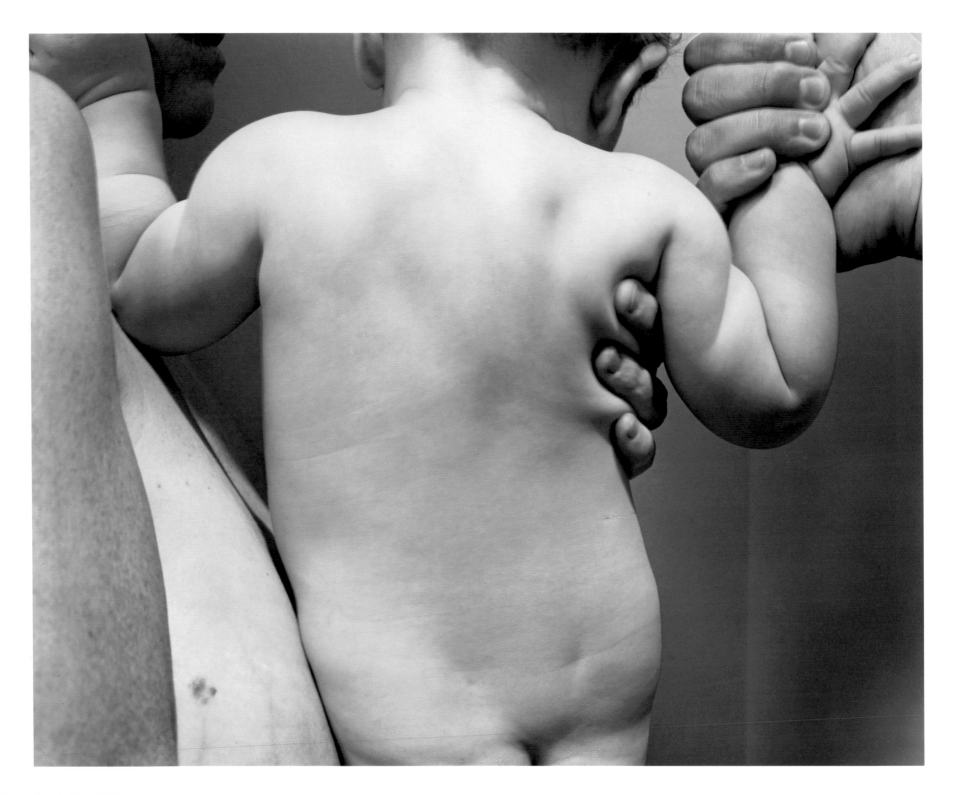

84 *Cambridge. 1986*

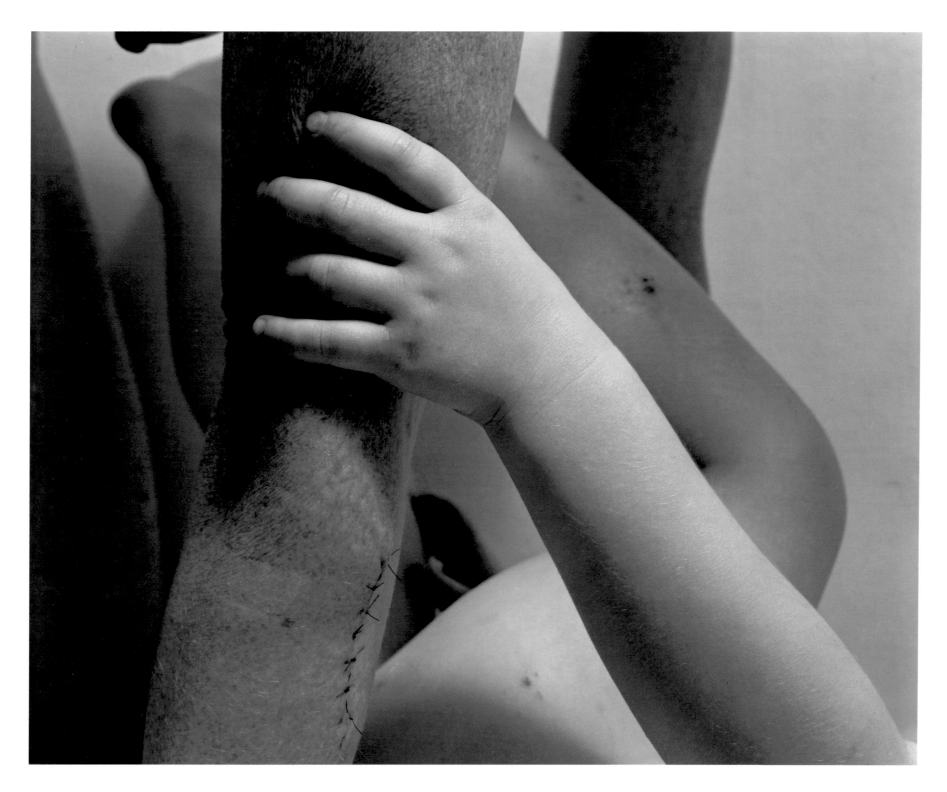

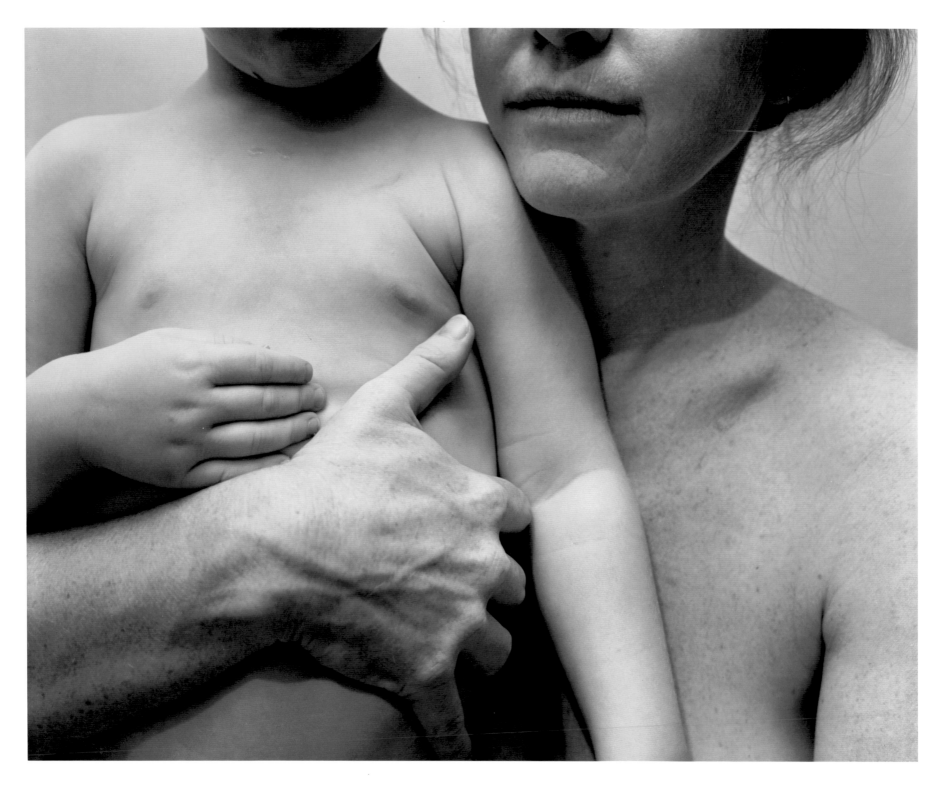

86 *Cambridge. 1985*

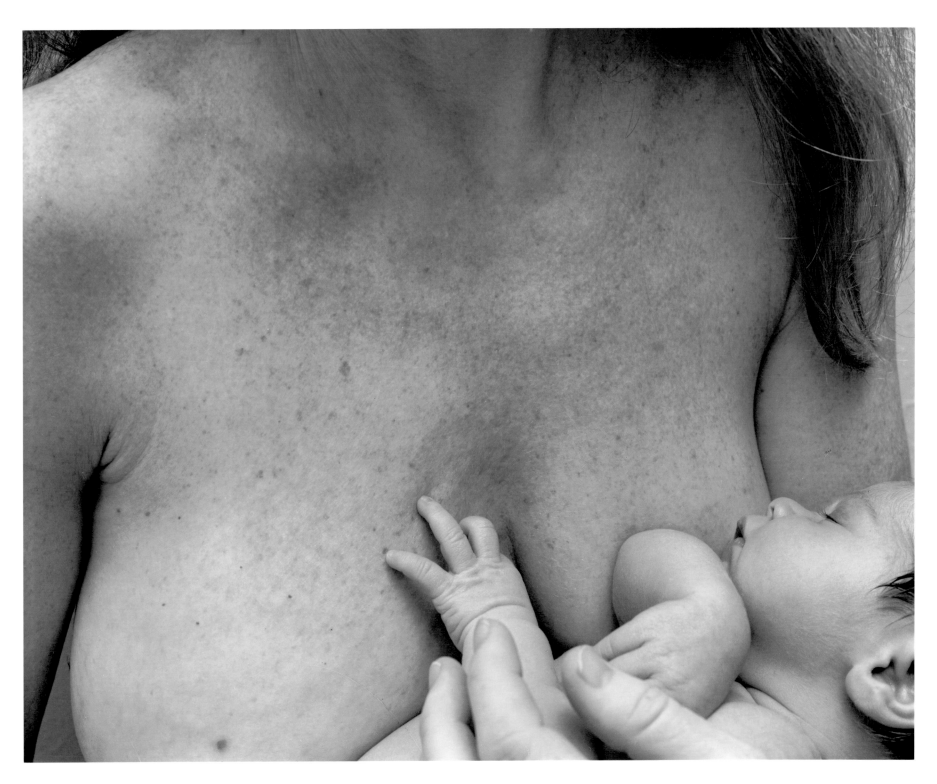

Bebe and Clementine, Cambridge. 1985 87

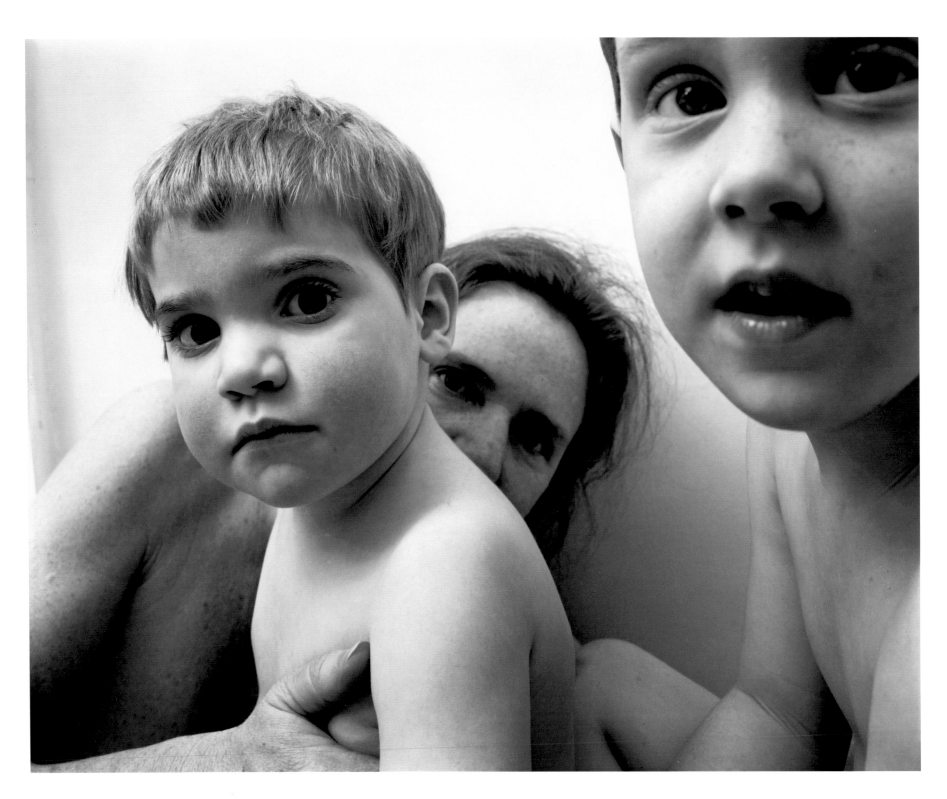

88 *Bebe, Clementine, and Sam, Cambridge. 1988*

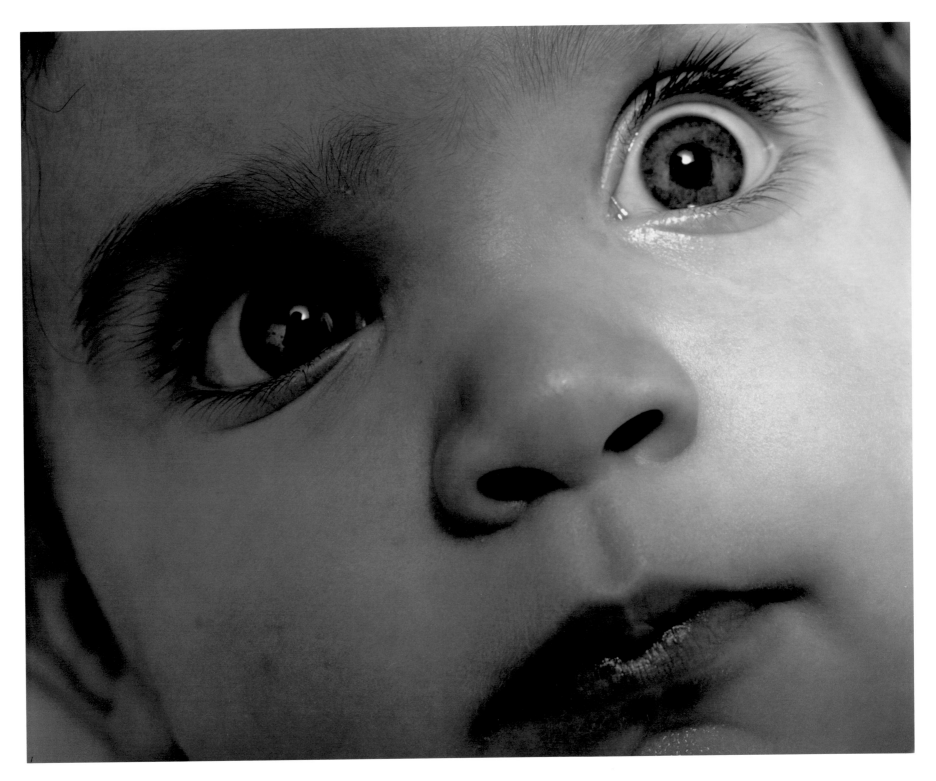

Clementine, Cambridge. 1986 89

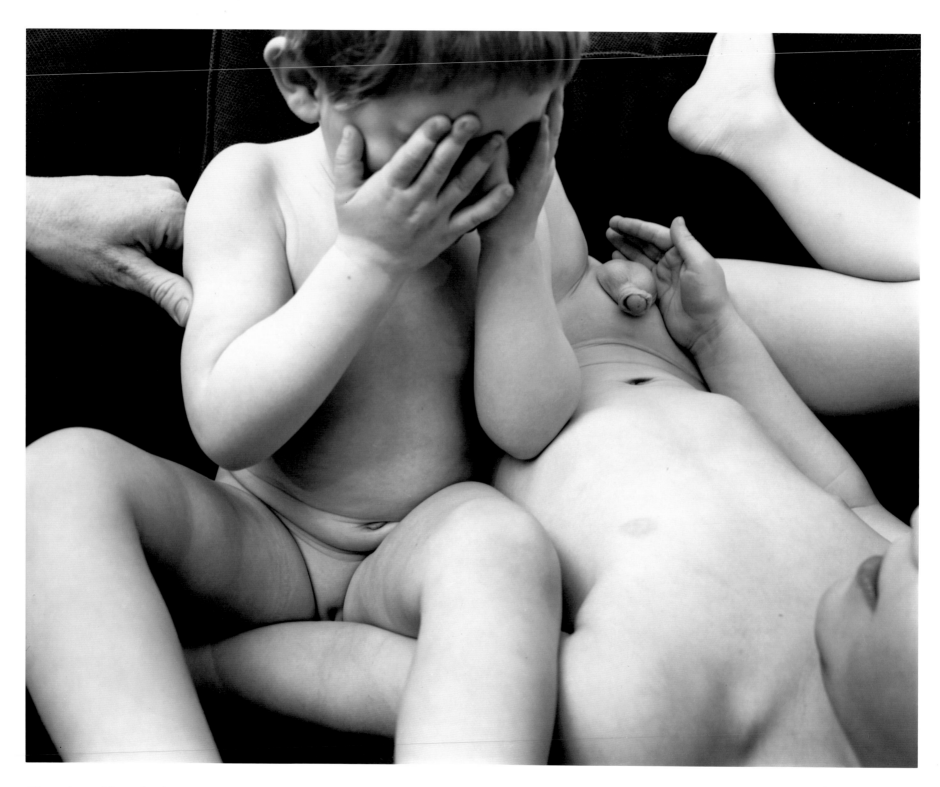

90 *Clementine and Sam, Cambridge. 1988*

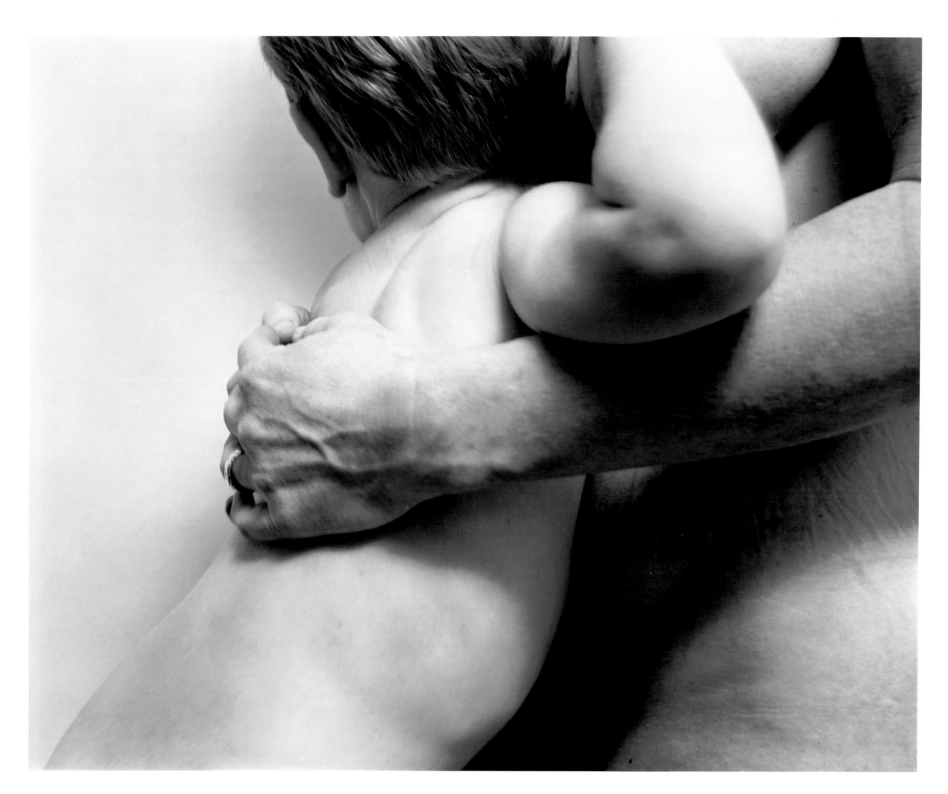

Cambridge. 1986 91

The Brown Sisters

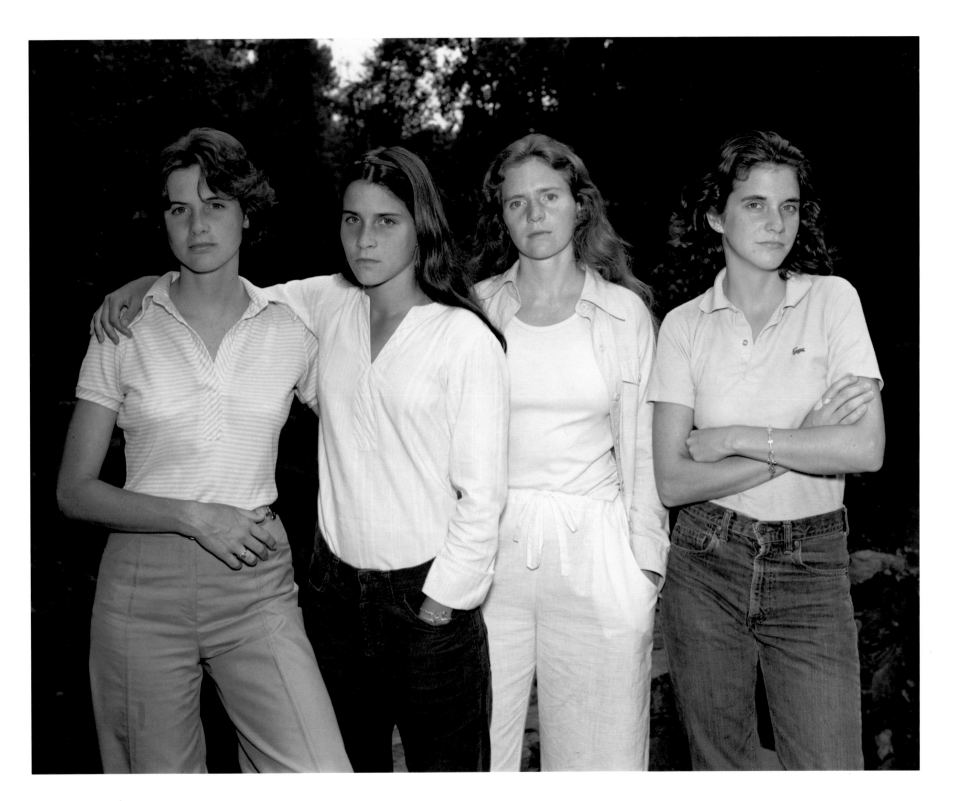

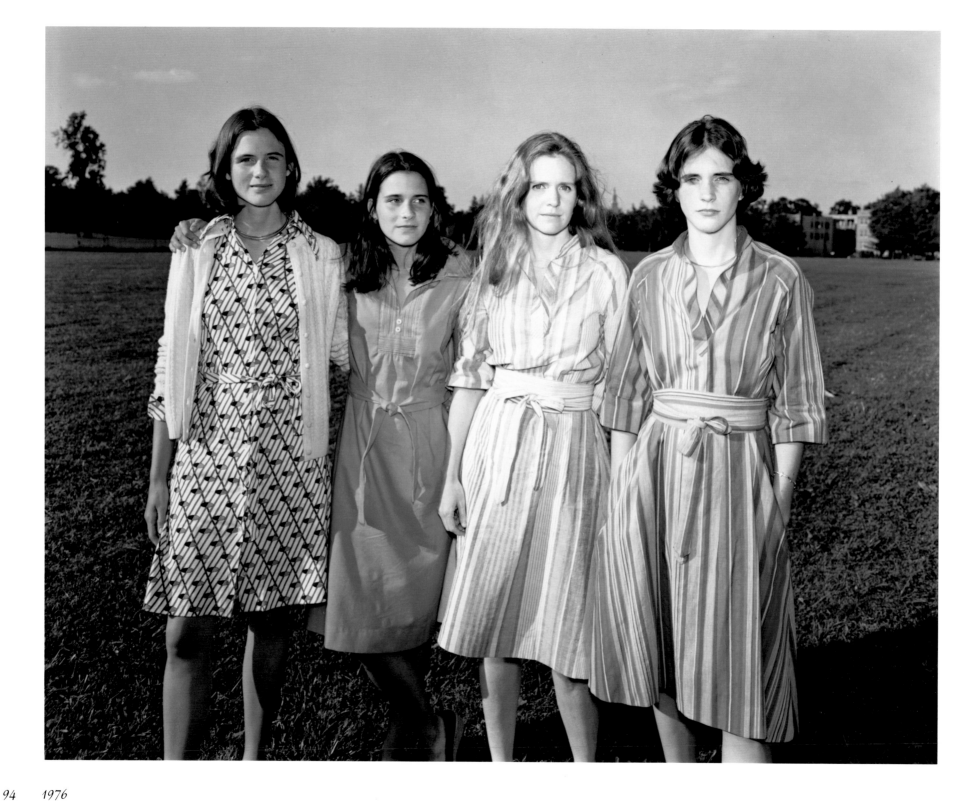

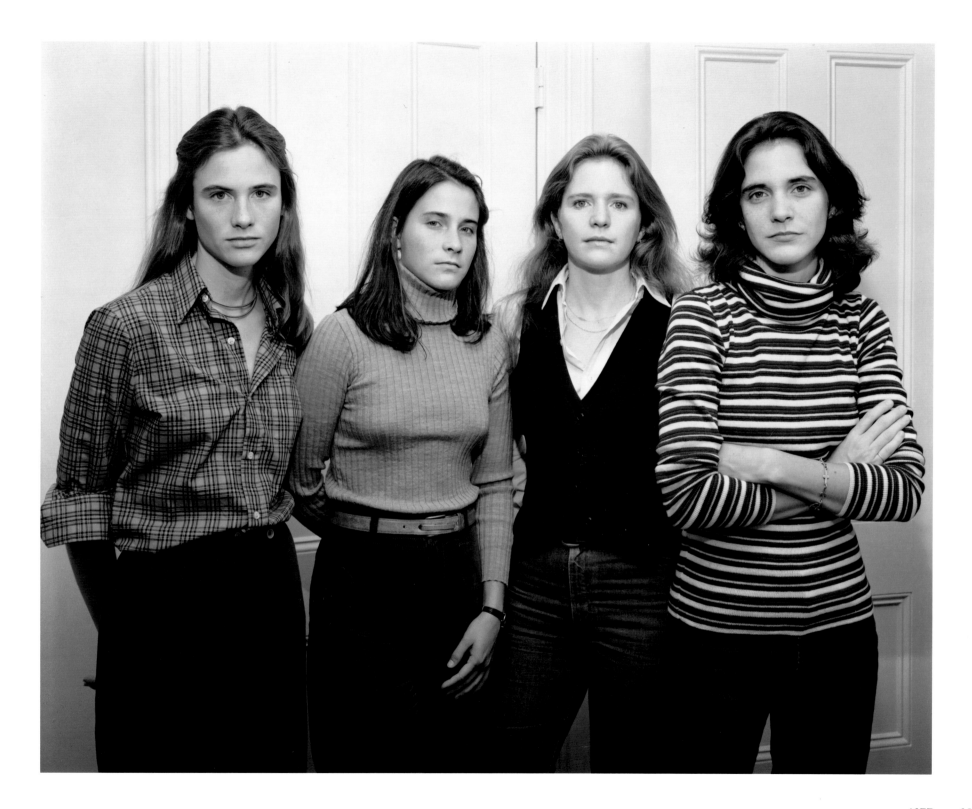

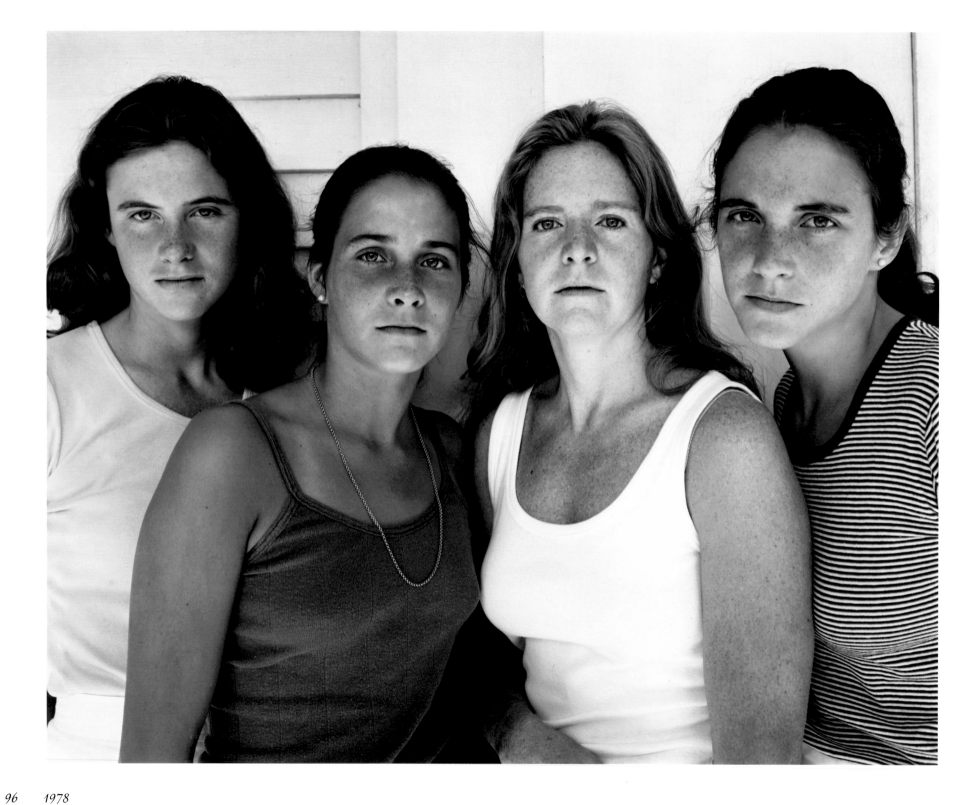

96 1978

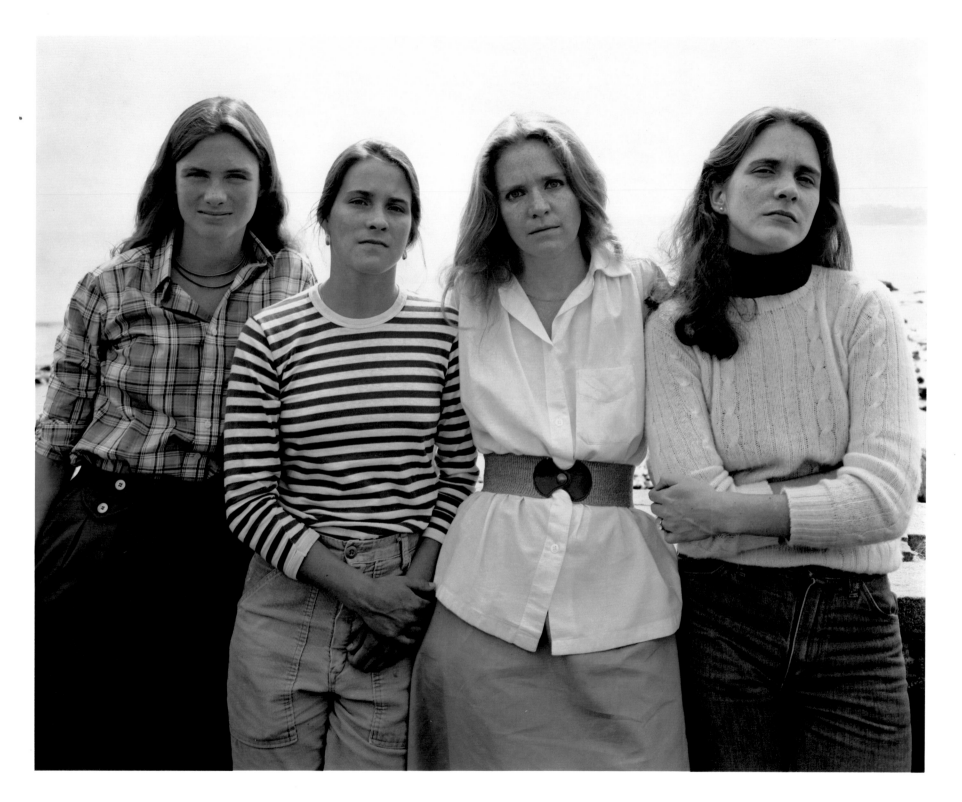

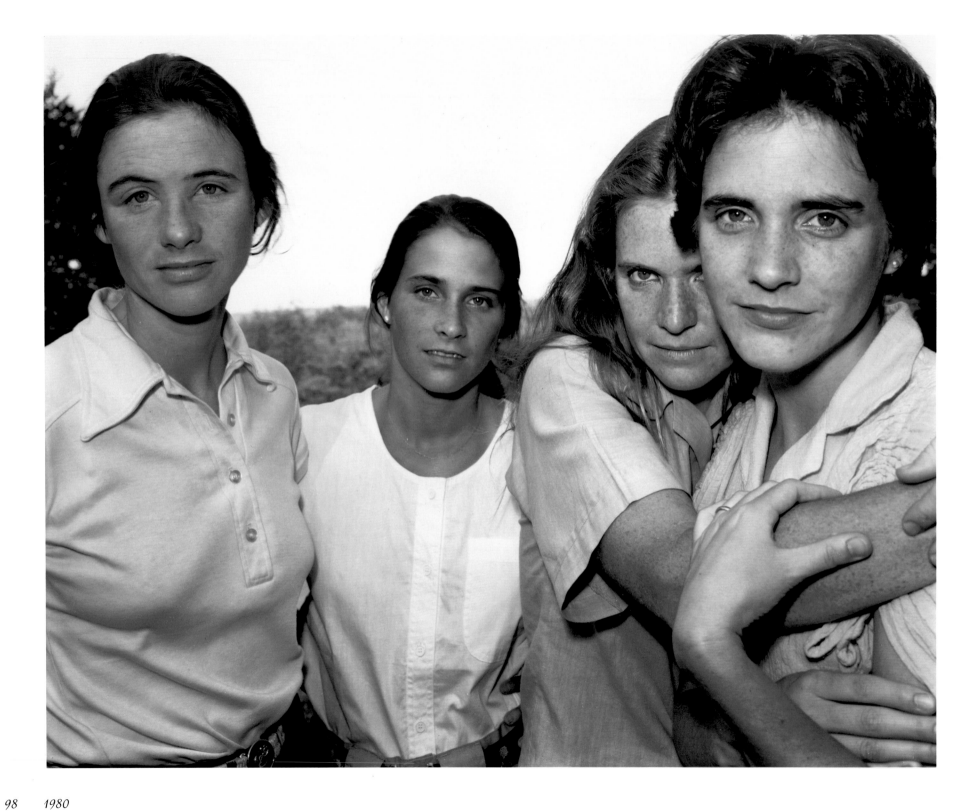

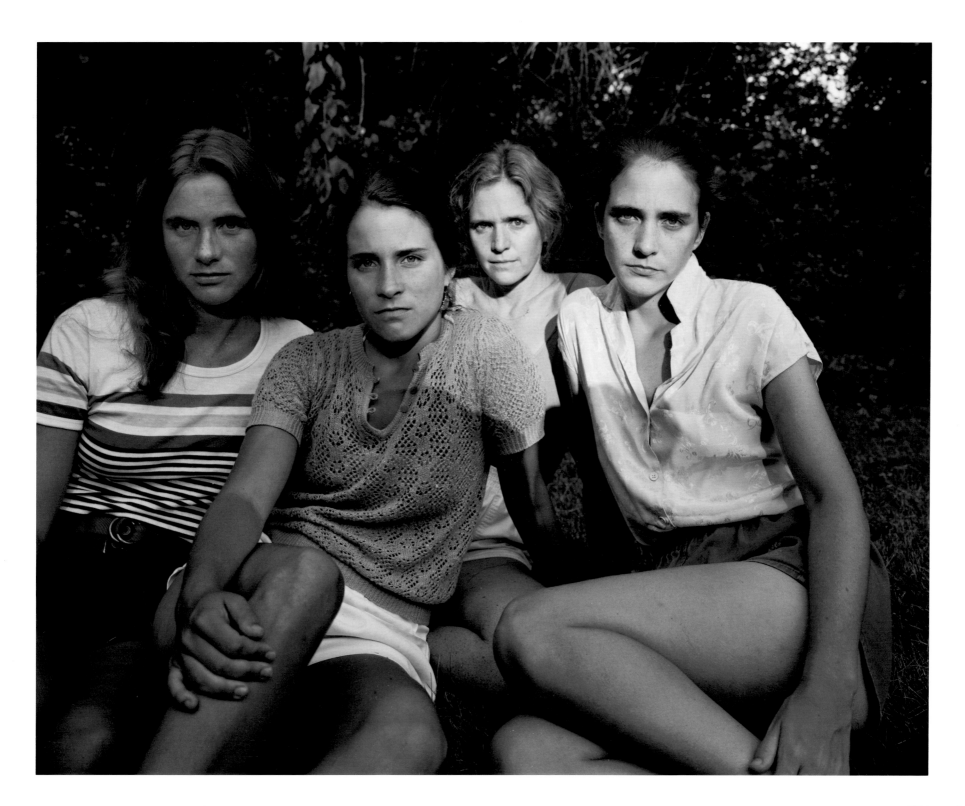

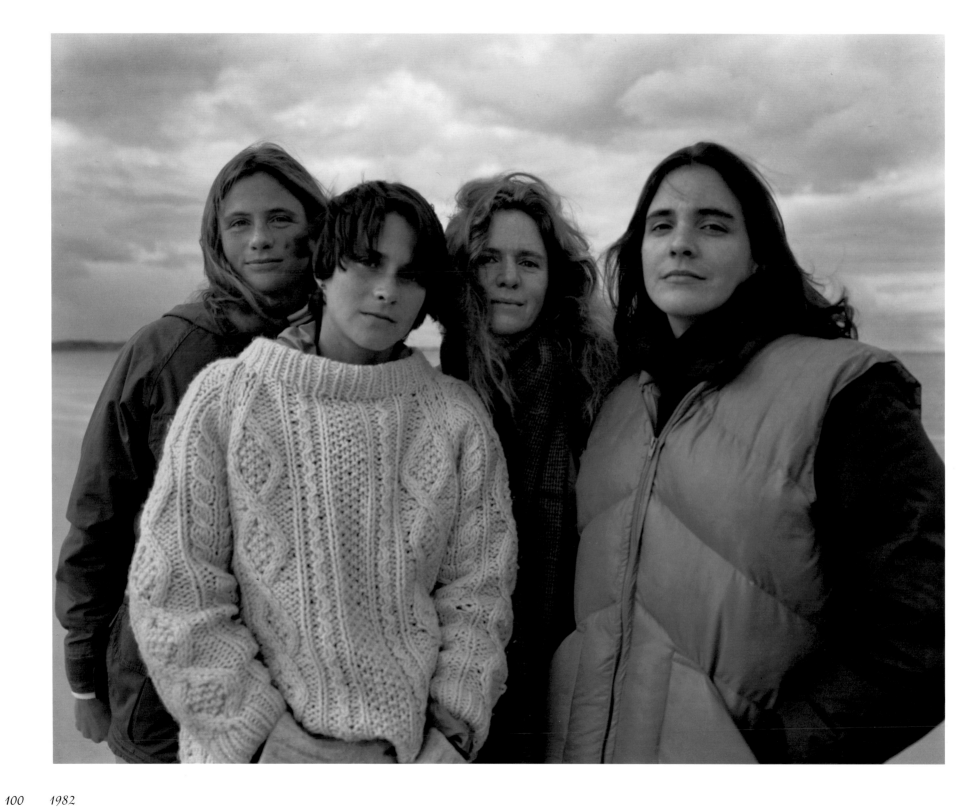

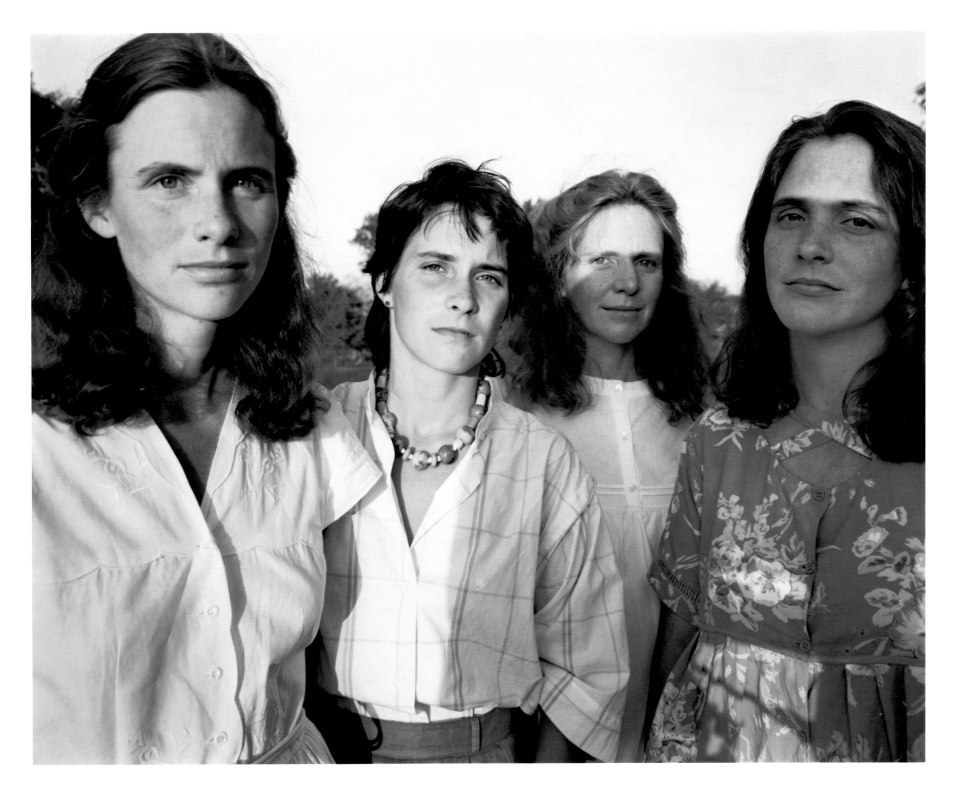

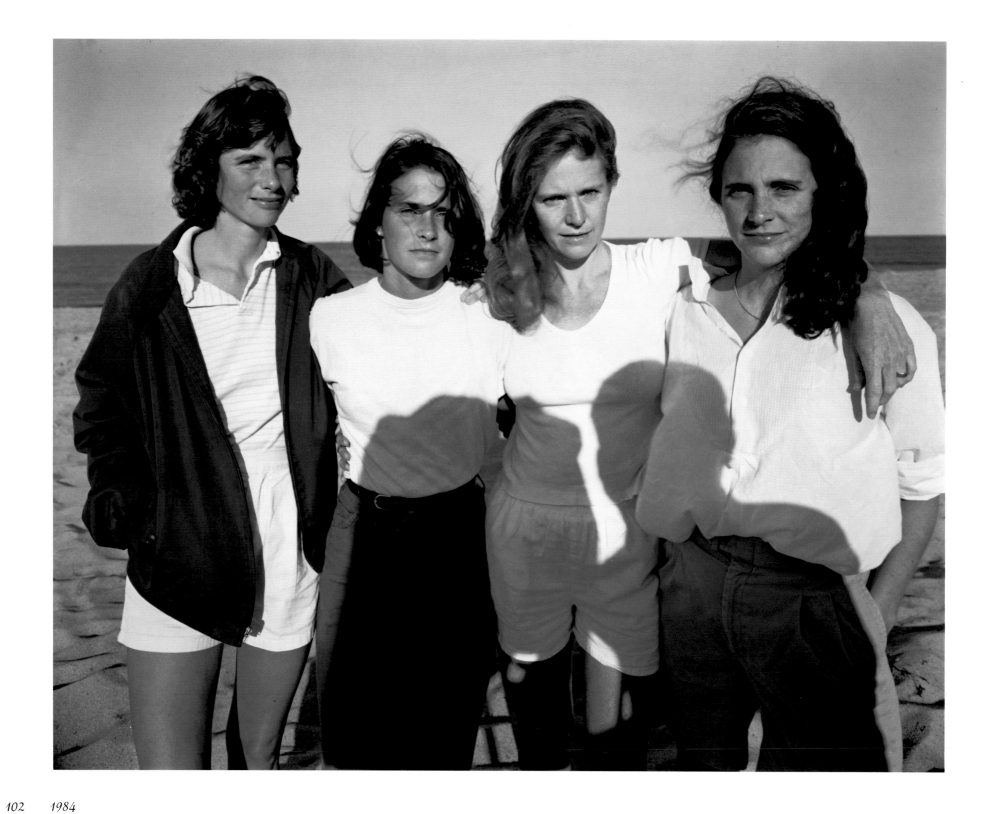

102 1984

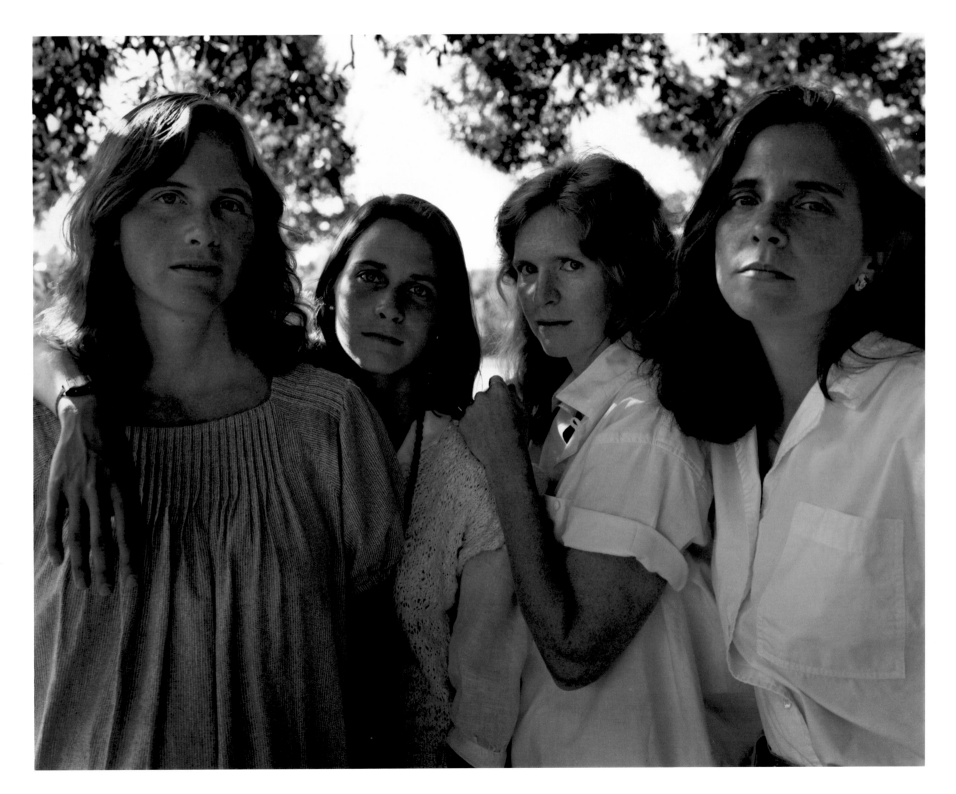

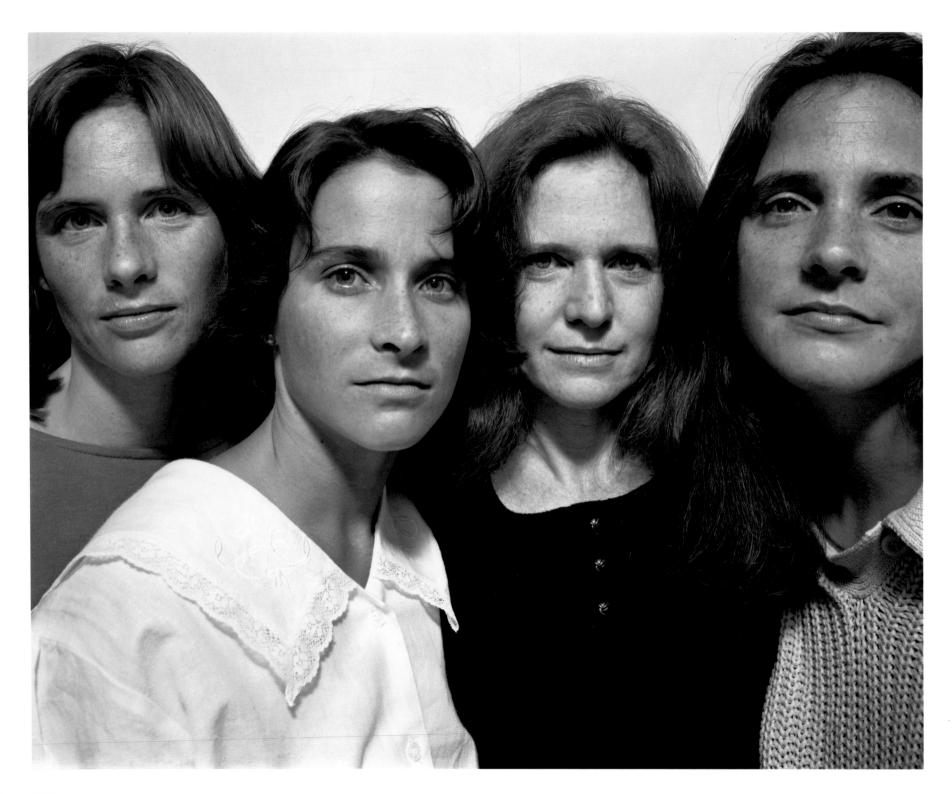

104 1986

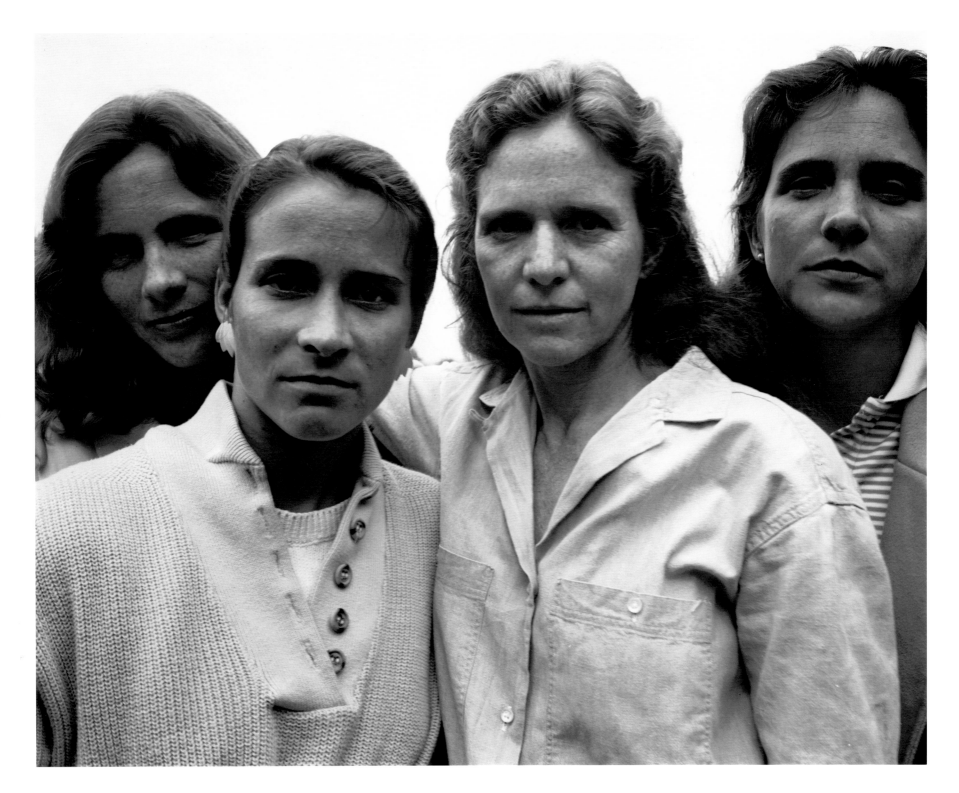

People with AIDS:
Excerpt from Work in Progress

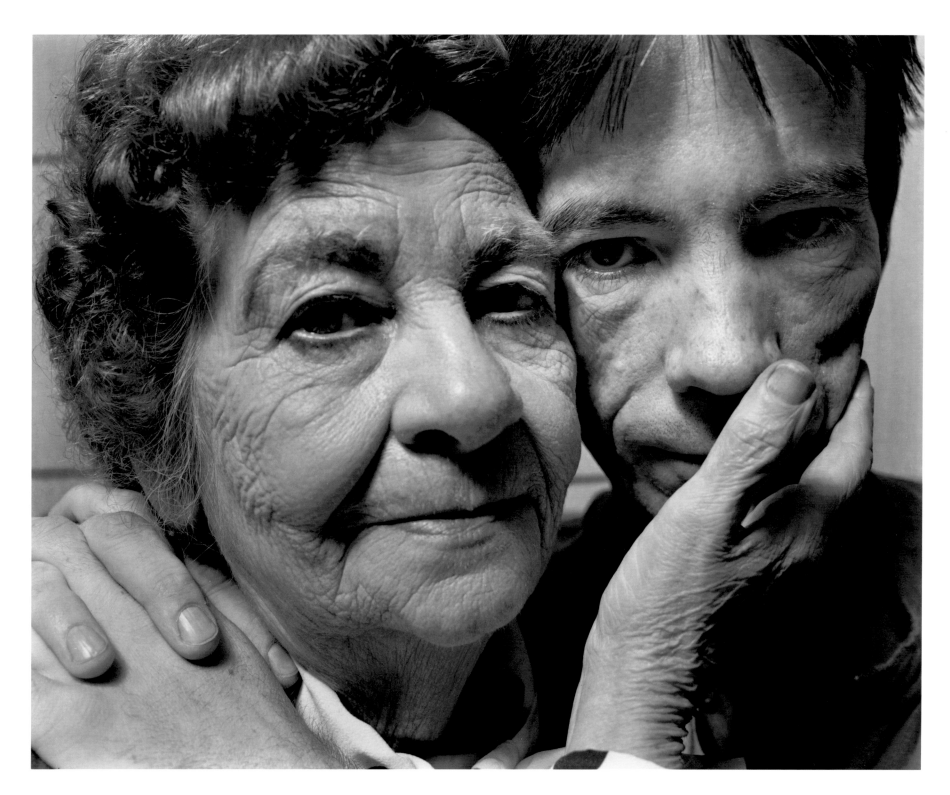

Tom Moran and his mother, Catherine Moran. August 1987 107

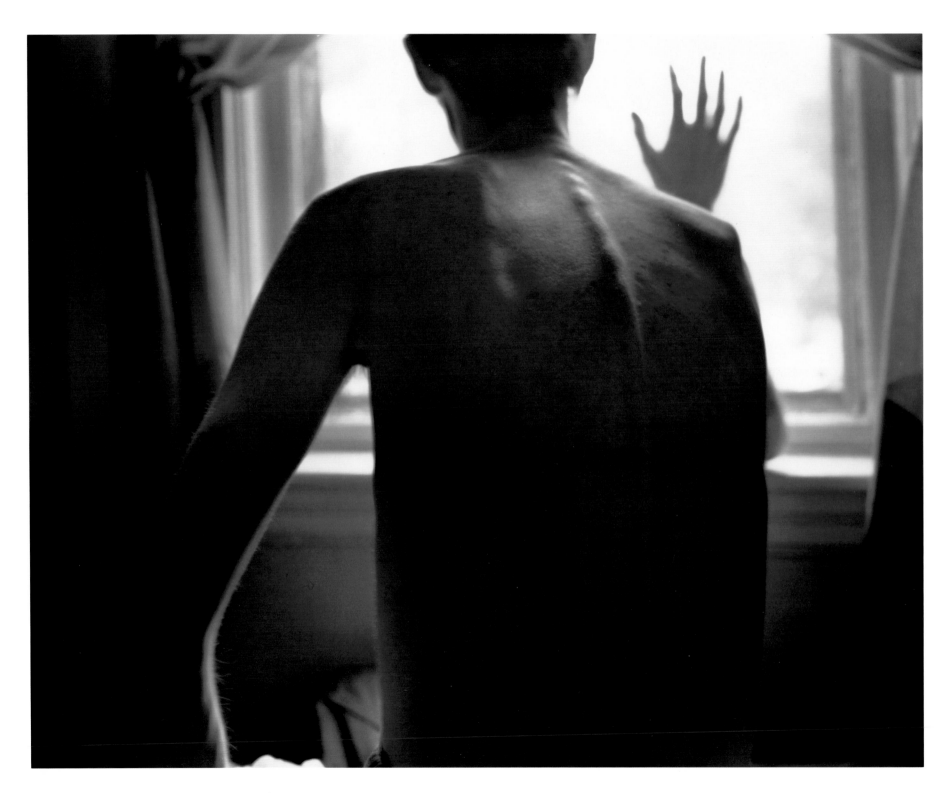

108 *Tom Moran. September 1987*

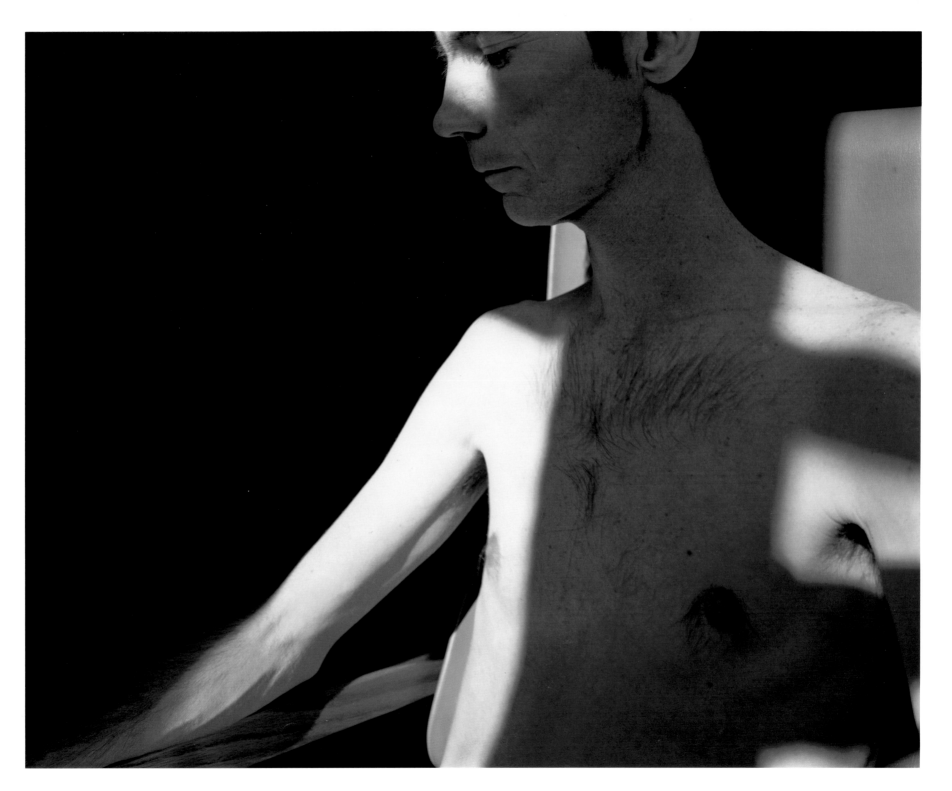

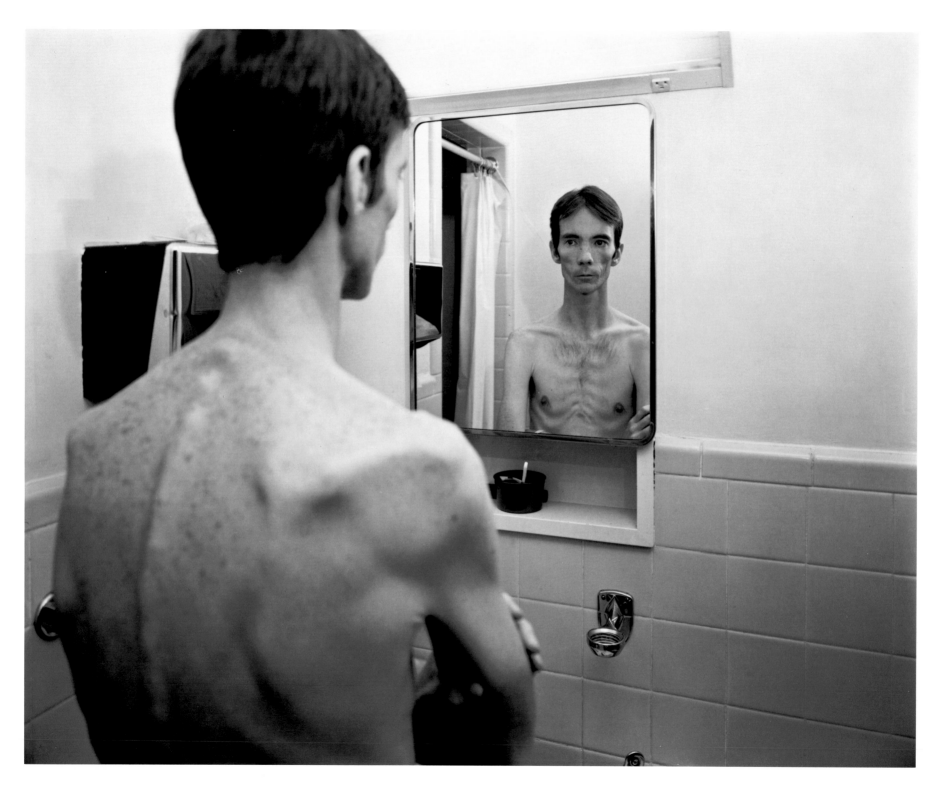

110 *Tom Moran. October 1987*

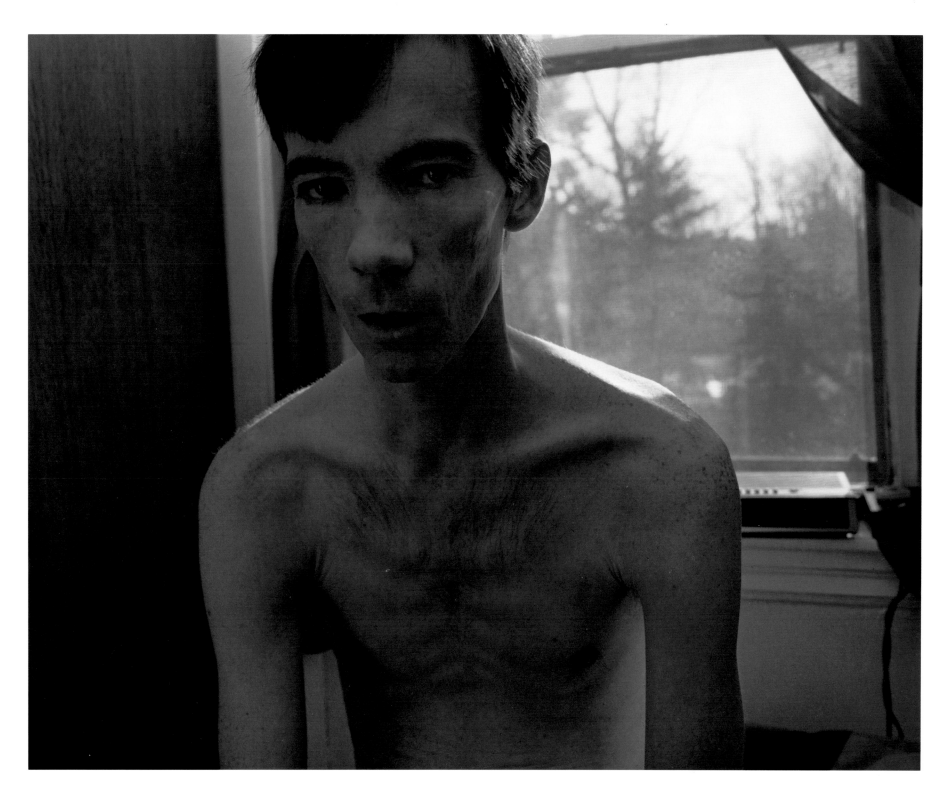

Tom Moran. November 1987 111

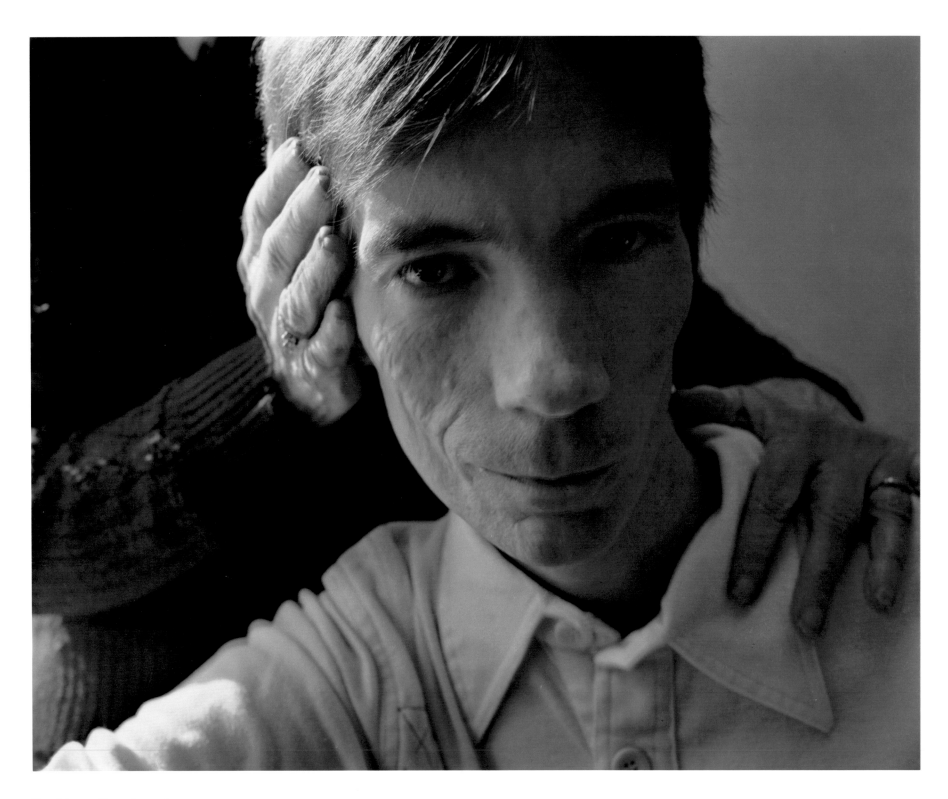

112 *Tom Moran. November 1987*

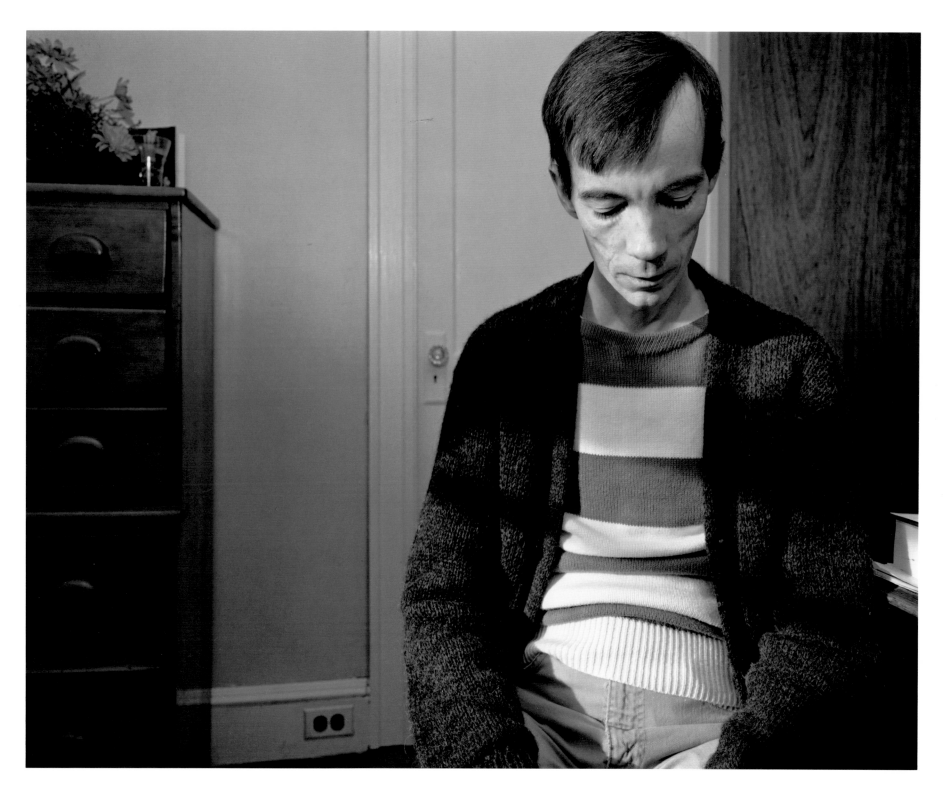

Tom Moran. December 1987 113

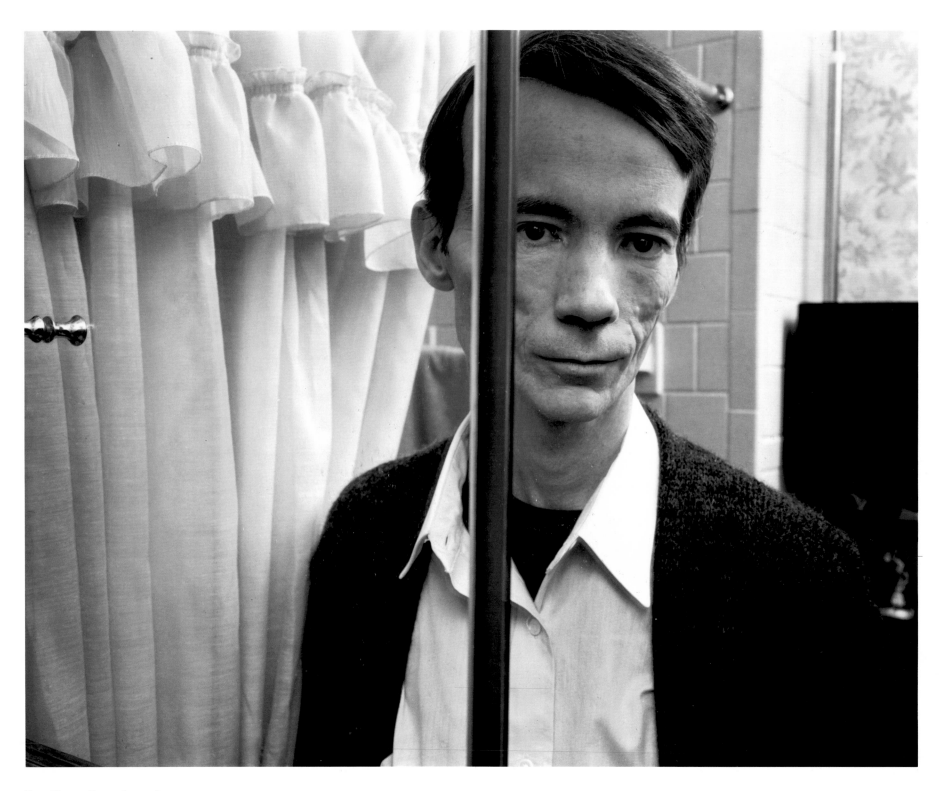

114 *Tom Moran. December 1987*

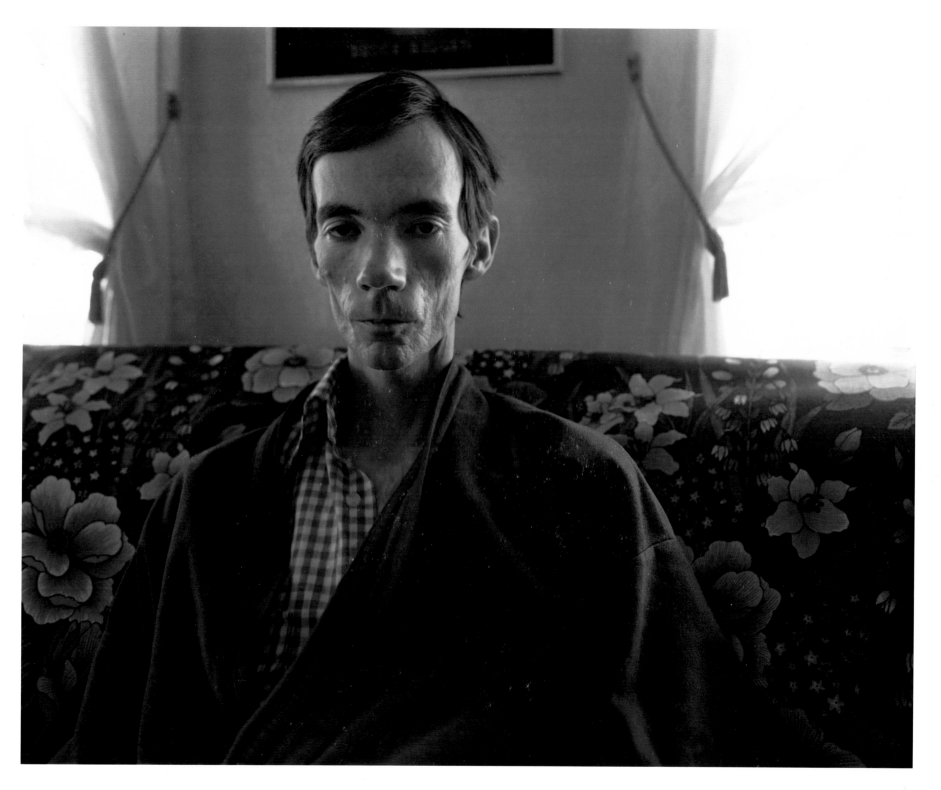

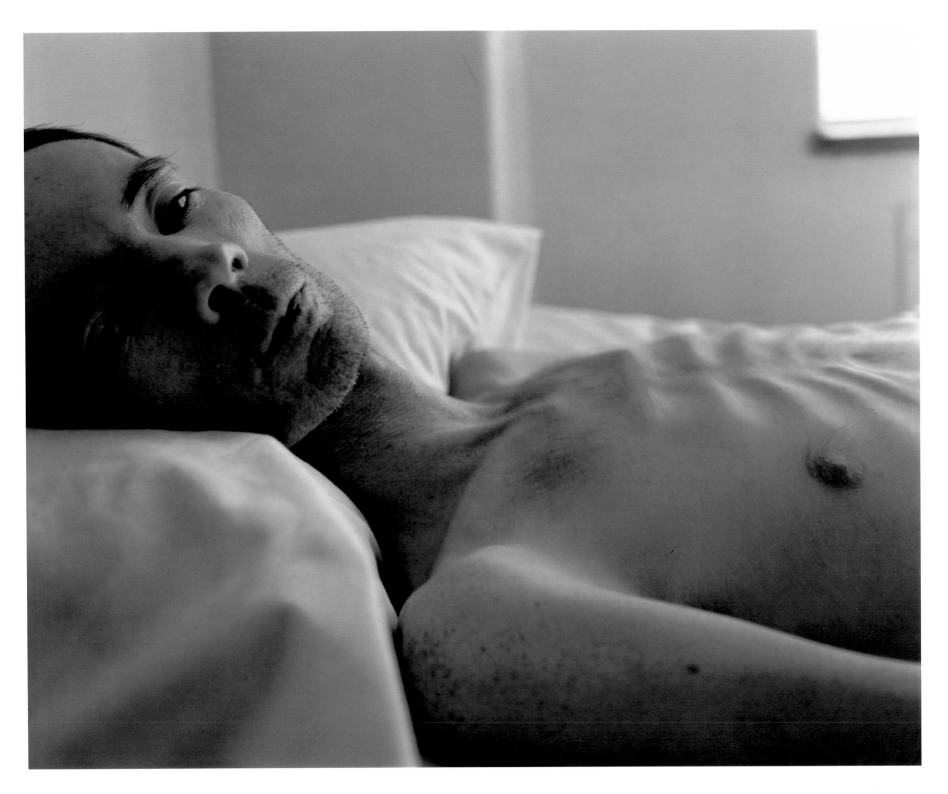

116 *Tom Moran. January 1988*

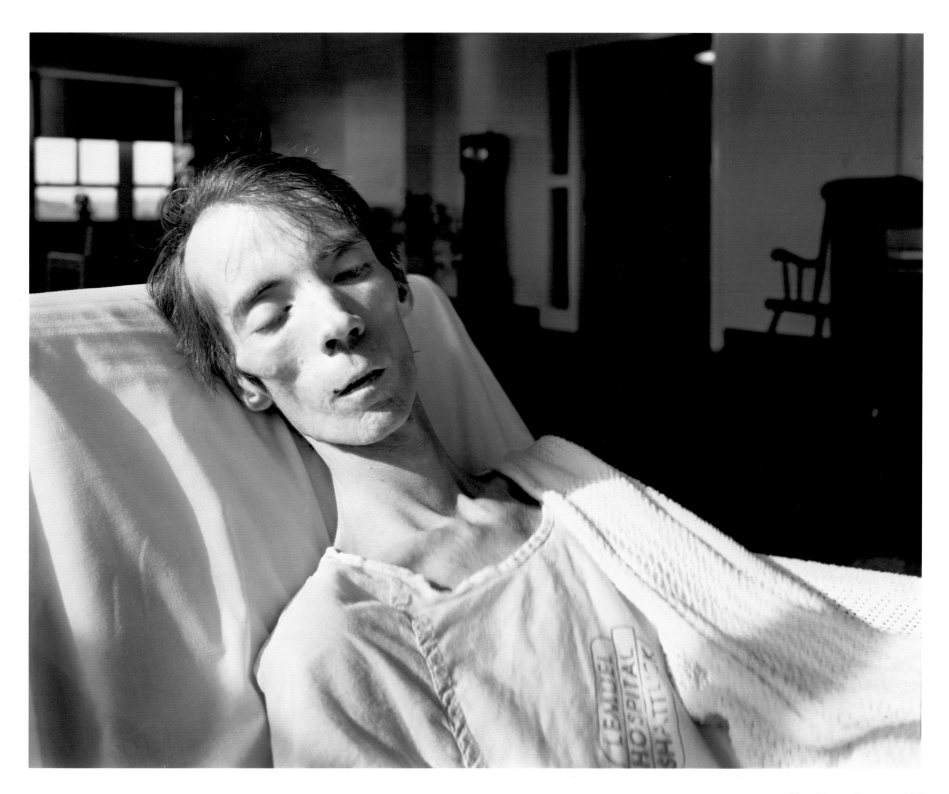

Tom Moran. January 1988 117

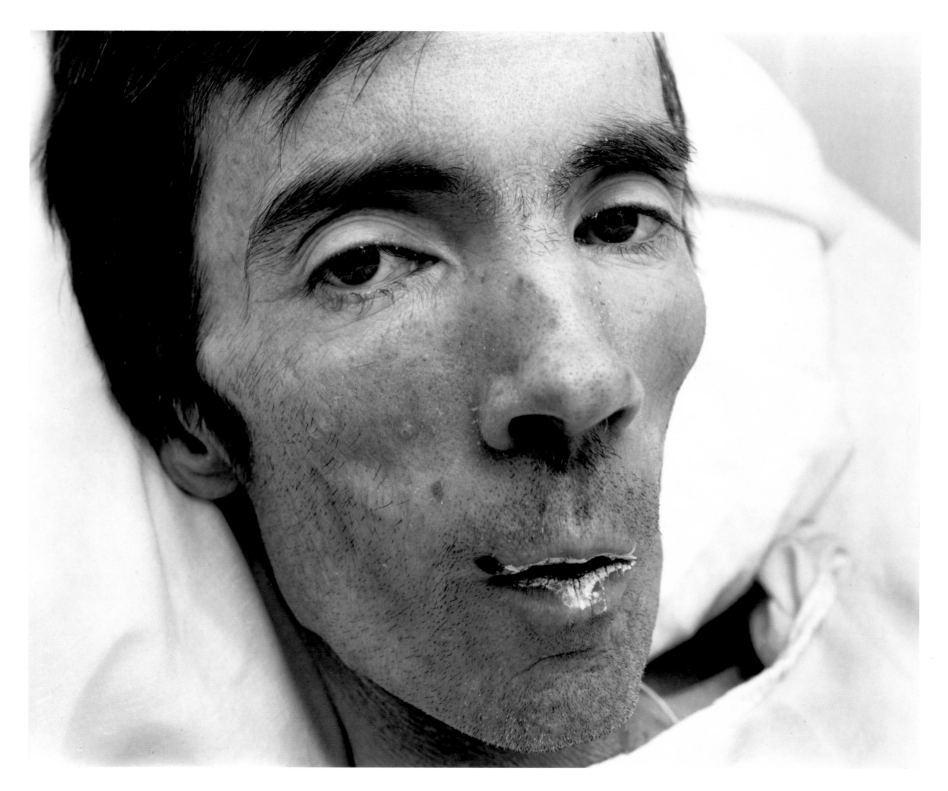

Nicholas Nixon:
Chronology and Bibliography

Compiled by Lisa Kurzner

1947 Born Detroit, Michigan

1969 B.A., American Literature, University of Michigan

1974 M.F.A., University of New Mexico

Currently Professor, Massachusetts College of Art, Boston

Awards

1976 National Endowment for the Arts Photographer's Fellowship

1977 John Simon Guggenheim Memorial Foundation Fellowship

1980 National Endowment for the Arts Photographer's Fellowship

1984 Englehard Award, Institute of Contemporary Art, Boston

1986 John Simon Guggenheim Memorial Foundation Fellowship

1987 National Endowment for the Arts Visual Artist's Fellowship

One-Person Exhibitions

1976 The Museum of Modern Art, New York

1977 Vision Gallery, Boston

1978 Light Gallery, New York

1979 Light Gallery, New York
 Vision Gallery, Boston

1980 Fraenkel Gallery, San Francisco
 Light Gallery, New York
 Vision Gallery, Boston

1981 Light Gallery, New York

1982 *Institute of Contemporary Art, Boston
 Rochester Institute of Technology, Rochester, N.Y.
 Fraenkel Gallery, San Francisco
 Edwynn Houk Gallery, Chicago

1983 Daniel Wolf, Inc., New York
 *Madison Art Center, Madison, Wis.
 *Friends of Photography, Carmel, Calif.

1984 *Corcoran Gallery of Art, Washington, D.C.
 California Museum of Photography, Riverside, Calif.
 Fraenkel Gallery, San Francisco
 Pace/MacGill Gallery, New York

1985 Art Institute of Chicago
 Ackland Art Museum, University of North Carolina, Chapel Hill

1986 Cleveland Museum of Art, Cleveland
 Fraenkel Gallery, San Francisco
 Edwynn Houk Gallery, Chicago
 Pace/MacGill Gallery, New York

*denotes showings of "Nicholas Nixon: Photographs from One Year," accompanied by the monograph cited below.

Selected Group Exhibitions

If a catalogue accompanied the exhibition, the catalogue and its principal author are noted.

1975 *New Topographics: Photographs of a Man-Altered Landscape.* International Museum of Photography at George Eastman House, Rochester, N.Y. Catalogue by William Jenkins.

1976 *Six American Photographers.* Thomas Gibson, Ltd., London.

Photography: Recent Acquisitions 1974–1976. The Museum of Modern Art, New York.

1977 *Christenberry/Eggleston/Gossage/Meyrowitz/Nixon/Shore.* Broxton Gallery, Los Angeles, Calif.

Court House. The Museum of Modern Art, New York.

Nicholas Nixon and Stephen Shore. Worcester Art Museum, Worcester, Mass.

New York: The City and Its People. Yale University, Yale School of Art, New Haven, Conn.

Contemporary American Photographic Works. Museum of Fine Arts, Houston. Catalogue edited by Lewis Baltz; introduction by John Upton.

Ten Contemporary American Photographers. Galerie Zabriskie, Paris.

1978 *Mirrors and Windows: American Photography since 1960.* The Museum of Modern Art, New York. Catalogue by John Szarkowski.

Nicholas Nixon/William Eggleston. The Cronin Gallery, Houston.

14 New England Photographers. Museum of Fine Arts, Boston.

Linda Connor/Nicholas Nixon. Longwood Gallery, Massachusetts College of Art, Brookline, Mass.

1979 *American Images: New Work by Twenty Contemporary Photographers.* Corcoran Gallery of Art, Washington, D.C.

1981 *American Children.* The Museum of Modern Art, New York. Catalogue by Susan Kismaric.

1982 *20th Century Photographs from The Museum of Modern Art.* The Seibu Museum of Art, Tokyo. Catalogue edited by Susan Kismaric and John Szarkowski; introduction by John Szarkowski.

The Contact Print 1946–1983. Friends of Photography, Carmel, Calif. Catalogue by James Alinder.

1984 *Les Ages et les villes: Frederich Cantor—Nicholas Nixon.* Paris: The American Center. Catalogue by Madeleine Deschamps.

1986 *Variants.* The Museum of Modern Art, New York.

1987 *Twelve Photographers Look at US.* Philadelphia Museum of Art, Philadelphia. Catalogue by Martha Chahroudi, published as: "Twelve Photographers Look at US." *Bulletin of the Philadelphia Museum of Art,* vol. 83, nos. 354, 355 (Spring 1987), pp. 18–19.

Portrait: Faces of the '80s. Virginia Museum of Fine Arts, Richmond. Catalogue by George Cruger.

Photographs from the Last Decade. San Francisco Museum of Modern Art, San Francisco.

Monograph

Nicholas Nixon: Photographs from One Year, Untitled 31. Introduction by Robert Adams, Carmel, Calif.: The Friends of Photography, 1983.

Published Lecture

"Nicholas Nixon," in *Photography: The Media of Multiple Choices.* Proceedings of the 1986 Midwest Regional Conference of the Society for Photographic Education, October 31 and November 1, 1987. Cincinnati, Ohio: Society for Photographic Education, 1987, pp. 19–33.

Articles and Reviews

Albright, Thomas. "The Return of the 'People Pictures,'" *San Francisco Chronicle,* April 13, 1982.

Allara, Pamela. "ICA/Boston—Frank Gehry/Nicholas Nixon," *Art New England,* vol. 3, no. 8 (October 1982).

Batson, Shannon. "Open-ended Statements." *Artweek,* vol. 21, no. 15 (May 26, 1984), p. 14.

Edwards, Owen. "Exhibitions: Skin Deep." *American Photographer,* vol. 17 (August 1986), pp. 22ff.

———. "Exhibitions: Terra Incognita." *American Photographer,* vol. 14, no. 2 (February 1985), p. 16.

Elliott, David. "Photography's Nixon Is No Tricky Nick." *Sunday Sun Times* (Chicago), June 20, 1982.

Foerstner, Abigail. "Photography: Portraits a Spontaneous Celebration of 'Everyday Heroes.'" *Chicago Tribune,* December 26, 1986.

———. "Photography: Barriers Fall Before the View Camera of Nicholas Nixon." *Chicago Tribune,* April 26, 1985.

Fraenkel, Jeffrey. Untitled essay on Nixon. *Archetype,* vol. 2, no. 2 (Spring 1981).

Goldberg, Vicki. "Books: Heating Up." *American Photographer,* vol. 11, no. 4 (October 1983), pp. 37–40.

Grundberg, Andy. "Review of Exhibitions: New York: Nicholas Nixon at Light." *Art in America,* vol. 67, no. 3 (June 1979), p. 146.

———. "Photography View: A Respect for Tradition." *The New York Times,* February 27, 1983.

———. "Photography View: Documents with an Air of Theater." *The New York Times,* May 22, 1983.

——— and Julia Scully. "Currents—American Photography Today." *Modern Photography,* vol. 44, no. 5 (May 1979), pp. 114–117.

Hagen, Charles. "Reviews: New York: Nicholas Nixon, Pace/MacGill; 'The Territory of Art.'" *Artforum,* vol. 23, no. 5 (January 1985), p. 92.

Hedgpeth, Ted. "Modernist Strategies." *Artweek,* vol. 11, no. 20 (May 24, 1980), pp. 1, 11.

Knafo, Robert. "Nicholas Nixon at Light." *Art in America,* vol. 70, no. 3 (March 1982), p. 142.

Lifson, Ben. "Photography: Boxed-In." *Village Voice,* vol. 24, no. 49 (December 3, 1979), p. 93.

———. "Photography." *Village Voice,* vol. 26, no. 1 (December 31, 1980–January 6, 1981), p. 65.

———. "Every Picture Tells a Storyville." *Village Voice,* vol. 26, no. 51 (December 9–15, 1981), p. 103.

Marable, Darwin. "The Span of Life." *Artweek,* vol. 17, no. 20 (May 24, 1986), p. 11.

Ratcliff, Carter. "Route 66 Revisited: The New Landscape Photography." *Art in America,* vol. 64, no. 1 (January/February 1976), pp. 86–91.

Robb, Christina. "Pictures that Tell Stories of Poverty." *The Boston Globe,* September 9, 1983.

Rubenfien, Leo. "Reviews: New York: Nicholas Nixon, Museum of Modern Art." *Artforum,* vol. 15, no. 4 (December 1976), pp. 66–67.

Sheehan-Burke, Julia. "Documents of Compassion." *Dialogue,* vol. 9, no. 4 (July/August 1986), p. 47.

Starenko, Michael. "Forever Young." *Afterimage,* no. 10 (October 1982), p. 17.

Theodore, Lynn Sloan. Untitled review. *New Art Examiner,* vol. 3, no. 10 (Summer 1976), p. 9.

Thomas, Alan. "Nicholas Nixon." *New Art Examiner,* vol. 12, no. 8 (May 1985), pp. 68–69.

Thomas, A. G. Untitled review. *New Art Examiner,* vol. 14, no. 8 (April 1987), pp. 41–42.

Thornton, Gene. Untitled review. *The New York Times,* January 27, 1980.

———. "Portraits That Inform Through Ambiguity." *The New York Times,* November 4, 1984.

Turner, Peter. "Nicholas Nixon: Photographs from One Year." *Creative Camera,* no. 237 (September 1984), p. 1530.

Westerbeck, Colin L., Jr. "Reviews: New York: American Images." *Artforum,* vol. 18, no. 9 (May 1980), pp. 76–79.

Wise, Kelly. "Reviews: Boston: Nick Nixon: Vision Gallery of Photography." *Artforum,* vol. 19, no. 8 (April 1981), pp. 73–74.

Zelevansky, Lynn. "Nicholas Nixon/Light Gallery." *Flash Art,* no. 106 (February/March 1982), p. 57.

Selected Publications with Reproductions of Photographs by Nixon

"4 Views of Boston, 1975." *The Real World,* no. 6 (June 1976), pp. 14–17.

Photography Year. New York: Time-Life Books, 1977.

Court House. A Photographic Document. Edited by Richard Pare; conceived and directed by Phyllis Lambert. New York: Horizon Press, 1978.

"Photographs by Nick Nixon." *The Real World,* no. 11 (Summer 1978), pp. 17–19.

American Images: New Work by Twenty Contemporary Photographers. Edited by Renato Danese, New York: McGraw Hill, 1979.

Carter Ratcliff. "Of Light and Myth and Dream." *Picture Magazine,* no. 15 (April/May 1980), n.p.

"Project." *Artforum,* vol. 20, no. 4 (December 1981), pp. 44–48.

"Four Sisters, Continued." *Artforum,* vol. 25, no. 5 (January 1987), pp. 102–06.

Photograph Credits

All of the photographs by Nicholas Nixon are lent by the photographer and are reproduced the size of the original. Credits for the other photographs reproduced as illustrations to the introduction are as follows:
Page 18. Walker Evans: The Museum of Modern Art, New York, gift of the Farm Security Administration. Paul Strand: The Museum of Modern Art, New York, purchase.
Page 19. Bruce Davidson: The Museum of Modern Art, New York, purchase. Garry Winogrand: The Museum of Modern Art, New York, purchase.
Page 25. Courtesy F. I. Brown.